Chinese Brush Painting

Chinese Brush Painting

This book is dedicated to the memory of Professor Joseph Shan Pao Lo.
Also to all my other tutors, students and friends in Chinese brush painting.

PAULINE CHERRETT

D&S
BOOKS

First published in 2000 by D&S Books

© 2000 D&S Books

D&S Books
Cottage Meadow, Bocombe,
Parkham, Bideford
Devon, England
EX39 5PH

e-mail us at:-
enquiries.dspublishing@care4free.net

This edition printed 2000

ISBN 1-903327-04-0

Editorial Director: Sarah King
Editor: Judith Millidge
Project Editor: Clare Haworth-Maden
Designer: Axis Design

Distributed in the UK & Ireland by
Bookmart Limited
Desford Road
Enderby
Leicester LE9 5AD

Distributed in Australia by
Herron Books
39 Commercial Road
Fortitude Valley
Queensland 4006

1 3 5 7 9 10 8 6 4 2

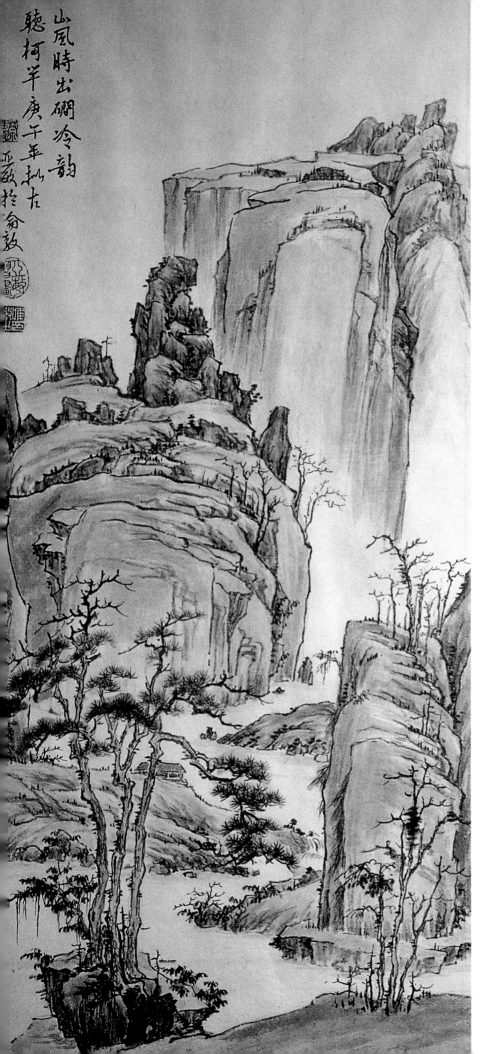

Contents

Introduction

Chinese brush painting has its origins in the distant past. Some of the earliest paintings were of figures on funeral banners and illustrations of everyday life commemorated on cave and tomb walls, complete with possessions. The sizes of the paintings varied, along with the amount of detail portrayed. Above all, Chinese artists followed their own inclination, ignoring ideas from the West, such as perspective, and absorbing the culture of their conquerors. In their turn they had an impact on neighbouring areas, such as Korea, Malaysia and Japan. Their religions, superstitions and beliefs were reflected in their paintings and motifs.

Early forms of calligraphy were scratched or painted onto shell and bone for divination. Bronze, pottery and wood were decorated from early times with symbolic symbols and shapes, often for funerary or ritualistic use. Silk was also a popular medium before the invention of paper.

Since these early times, the Chinese have looked to the work of the past, copying the 'masters' in order to learn. The extent to which each master copied earlier works is a matter of debate. But each artist is capable of adding something of themselves,

The plum is indicative of fortitude – able to withstand the trials of winter. The Ku beaker in bronze reinforces this symbolism.

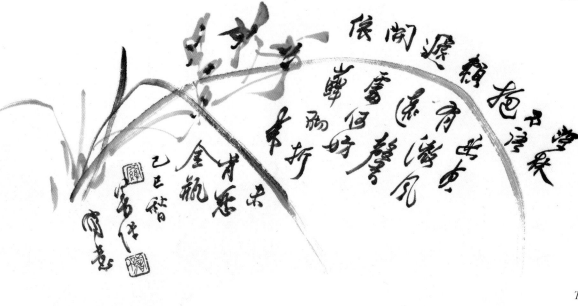

The flexible, fluid nature of the orchid is echoed in the calligraphy of Joseph Lo.

even when looking back to the past masters' techniques and styles. It is easy to mistake a painting from the 9th or 10th century for a modern version.

Some emperors, such as Hui-zong (Hui-tsung) (1082–1135), who promoted the Academy (life-like) style, established special styles and schools. He also encouraged beautiful calligraphy, and would often 'sign' a painting he approved of, along with other masters, which makes subsequent validation difficult.

China is a large country, with cities and regions separated by difficult terrain, so many styles of painting evolved quite separately from each other. Some styles have disappeared, others have evolved, and yet more have merged. There are also many folk-painting traditions.

There are two main styles of Chinese brush painting: *Gongbi*, often called meticulous, outline or contour painting; and *Xieyi*, boneless or freestyle painting. Both place great importance on brush strokes and linework. Art institutes in China require students to practise calligraphy, linework or grass orchids every day, in order to make their brushwork fluid and flowing.

Professional painters who produced realistic versions of their subject were not always as highly regarded as the scholar painters (or literati) who painted for their own satisfaction in a more 'spiritual' style. They painted subjects such as the 'Four Gentlemen' (plum, orchid, bamboo and chrysanthemum) for their virtuous qualities. Chinese brush painters strive to achieve *qi (chi)*, often described as the 'essence' in their paintings. This can be acquired by following certain principles, or simply by being in the right frame of mind for the subject.

These principles look at the interplay between the following contrasts: dark and light, wet and dry, large and small, long and short, thick and thin, dense and sparse. If you achieve three of these in your painting, you may achieve *qi*.

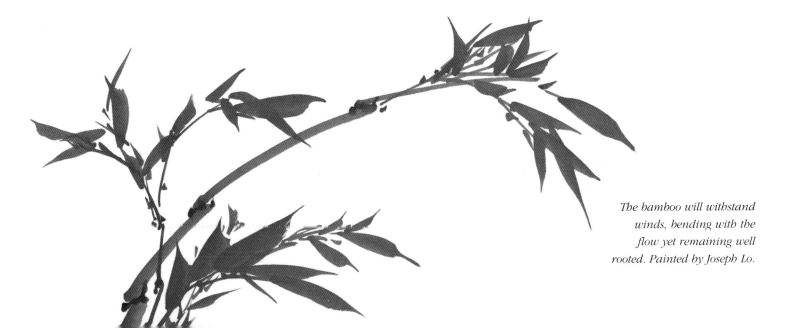

The bamboo will withstand winds, bending with the flow yet remaining well rooted. Painted by Joseph Lo.

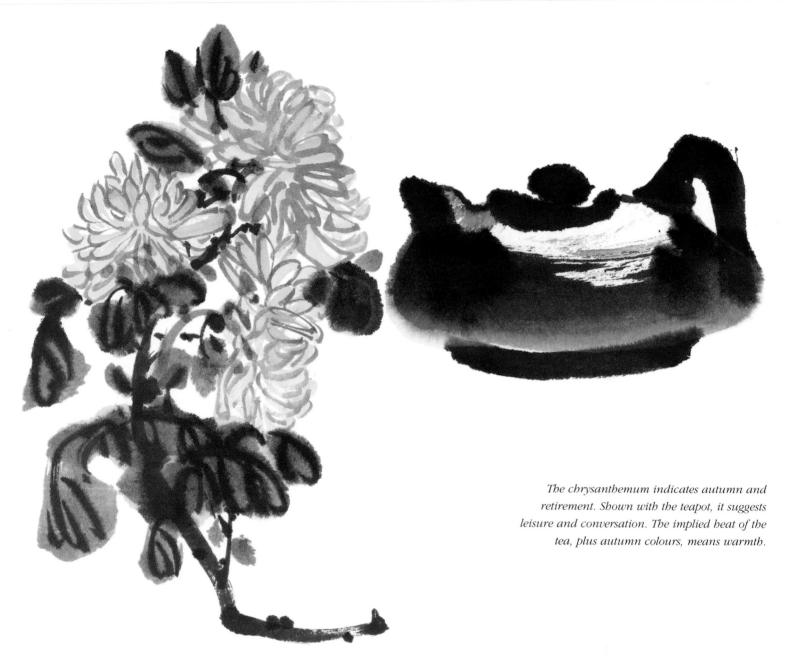

The chrysanthemum indicates autumn and retirement. Shown with the teapot, it suggests leisure and conversation. The implied heat of the tea, plus autumn colours, means warmth.

Chinese or Oriental composition is quite different to Western approaches to art. The Oriental style tries to capture a 'moment in time', which might include only part of a larger subject. The Western world generally takes an overall view of a subject, and is not so likely to abbreviate a picture. The Oriental way of presenting a picture, its framing and preservation are quite at odds with Western concepts. In the West we have a feeling of permanence rather than transience. Paper, and therefore scroll paintings, were not considered or expected to be long-lasting by the Chinese. It is only in recent years that paintings have been deliberately preserved.

Chinese brush painting does not seek to 'include every leaf'. Instead it contains only enough for recognition of the subject and its character – rather like a caricature, in fact. The attitude of the subject is all important. The interplay of brush strokes, and the space surrounding them, is carefully orchestrated within a painting. It is not sufficient to paint on a larger sheet of paper and then to cut it to size. The relationship of the strokes to the edges of the paper must be considered while painting.

The West has been fascinated with Chinese art for centuries, but, even so, the Western taste is for the more picturesque rather than the esoteric styles. Therefore the *Gongbi* style will probably have more devotees than the *Xieyi* style. An increasing number of exhibitions display oriental culture and related arts, with many including work of a high standard, especially in the *Xieyi* style, and this will create a more 'informed' audience.

Many artists are fascinated by the fact that Chinese paintings often leave some elements to the viewer's imagination; it is said that the ideal painting is just a piece of white paper – the viewer can visualise a new painting each day!

Equipment and materials

Equipment and materials

Chinese brush painting involves the use of traditional equipment and materials. As with many national traditions, the various accessories are often appealing in themselves. In the past, scholars and artists revelled in beautiful objects, which created a whole genre of antiques called the 'scholar's desk'. They include both the essentials and fringe objects which help create the ideal surroundings for the art to flow.

Although costly equipment can be purchased, without the necessary *qi* in the painting, the expense is wasted. Wonderful paintings can be achieved with ordinary, but appropriate, equipment. The main items are called the 'Four Treasures' and consist of the ink stone, ink stick, paper and brush. Good advice on equipment is difficult to find, as very few suppliers are also painters. Many teachers either sell equipment, or are able to advise on the most appropriate, or more easily obtainable, items. There are various specialist mail-order firms, and some good art shops may have a limited range. Do make sure that the items for sale are Chinese, as some of the equipment stocked (mainly the ink and brushes) is Japanese and may not be so appropriate.

Ink stones

Ink stones (*yan*) are carved from slate or stone, the best coming from Duan. It is ideal to have one with a lid, so that the ink does not dry up too quickly. The surface must be neither too smooth

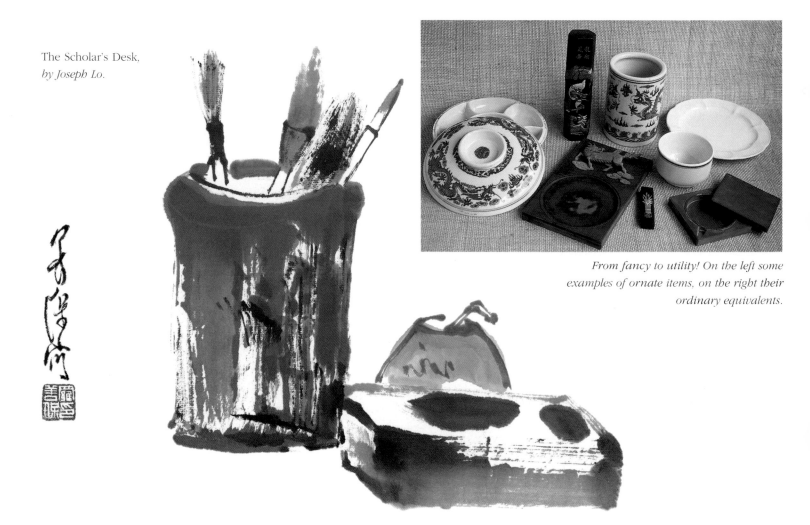

The Scholar's Desk,
by Joseph Lo.

From fancy to utility! On the left some examples of ornate items, on the right their ordinary equivalents.

Very large purple ink stone with a small and large marking (28cm/11in diameter). Small stone (10cm/4in diameter). A set of

Cultural Revolution ink sticks, a round stick and a '101' stick. Two animal water droppers can be used to drip a small

amount of water onto the stone. The calligraphy practice fan is by Primrose Thornbury.

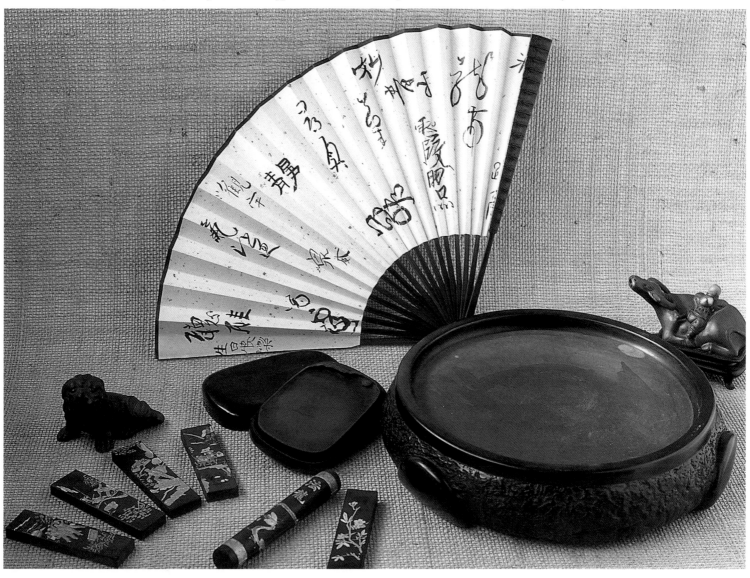

nor too rough. Beautifully carved versions are available, as well as student-quality stones. Square, circular, rectangular, hexagonal or free-style, they are available in a variety of colours and patterns. Some make use of the natural layers in the stone and have been carefully considered before carving.

There are many wonderful antique stones, in a variety of shapes and sizes. Those used in the past by famous or respected artists are highly prized. The size can vary enormously, from tiny travelling stones to large studio versions that can hardly be lifted. The lids may be made of the same stone or slate as the main grinding surface, or the stone may have a wooden lid or be enclosed in a fitted box. It is all down to taste, availability and expense. You should look after the stone to prevent chipping or breakage, and if too much dried ink accumulates to allow smooth grinding, clean it with a cloth (or a very soft brush). If you paint at home, and travel to a group as well, you might con-

sider buying two stones. Often the first stone purchased is cheaper and smaller, so once you are addicted to this style of painting buy a better, larger version, for your studio.

The stone should be large enough for the size of painting planned – too much ink will take too long to grind; too small a stone will interrupt the painting unnecessarily and will prevent a smooth, rhythmical painting movement. For convenience, many painters use liquid ink today, but some inks are of poor quality. Some enthusiasts believe that Western artists need to prepare the ink on a stone in order to set the scene and to achieve the right frame of mind. After using liquid ink, remove it thoroughly from the brush by rinsing it in clean water.

Above all, grinding the ink is a time for reflection on the work ahead, and for preparing both the brush and the wrist. Good ink may help to produce better work, as it is fresher, lacks preservatives, and thus penetrates the paper properly.

Seven shades of ink

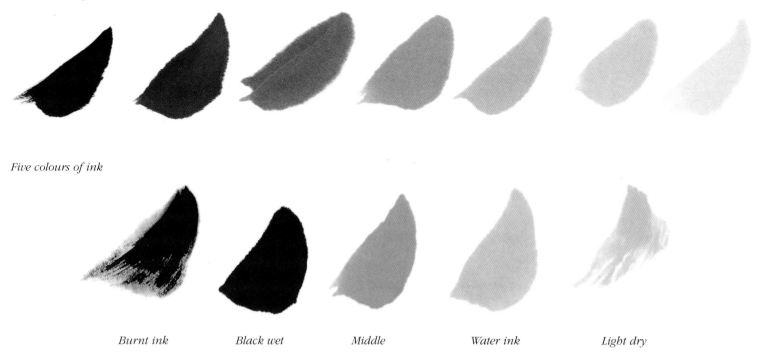

Five colours of ink

| *Burnt ink* | *Black wet* | *Middle* | *Water ink* | *Light dry* |

Ink

Ink (*mo*), is usually supplied in stick form. It is prepared from pine, oil or lacquer soot. The soot can come from differing parts of the kiln, that from the top and furthest from the fire being regarded as better than 'neck' and 'body' soot. There is also 'vegetable soot' (from burnt rice ash), which is said to be good for painting hair, beards and feathers.

Ink sticks are often highly decorated, and are available in various sizes and shapes, often described as one ounce, two ounce, etc. There are several types, sometimes with numbers such as '101', '102', '104', etc., or with names like 'Purple Light' and 'Dragon's Goal'.

When buying an ink stick, look for a matt surface and a lighter weight. A glossy, heavier stick probably has too much resin. Additional glue can be mixed while painting once the techniques are learnt, and by using suitable natural product such as bone or horn glue. Take care of the ink stick by propping it on the edge of the ink stone, or finding a rest specifically for it. This can be a proprietary item or something like a chopstick rest, which will allow the stick to dry. When not in use, store it away from damp or heat.

Paper

The paper (*zhi*) used for Chinese brush painting can have many different specifications. There are four main types: practice papers (semi-absorbent), absorbent papers, sized papers and special papers. With so many papers available in the Orient, and an increasing number in the West, it is important to keep samples of the different papers, and to make notes about the results achieved and your preferences. Try as many as you can and make a file or book for reference.

Practice papers are best for the beginner, and good paintings can easily be framed, whatever the paper. Grass paper (*mao bian*) is a straw colour, and is available as A3 sheets or larger. For those who do not like the colour of grass paper, there are Japanese and Taiwanese papers in roll format called 'Moon Palace', which are very white and bland in texture, but are popular with flower painters. This paper is strong and is also useful for backing.

Absorbent papers fall mainly under the description of *xuan* paper, which has many variations, such as single-, double- or triple-ply *xuan*, or bark *xuan*. The absorbency varies, both between the different types of paper and even between batches of the same paper, making good control essential.

A very absorbent paper is useful for painting furry animals, but a slightly sized paper is preferable for flowers and insects. Paper available in some art shops is often very absorbent – try to obtain a less 'fuzzy' paper to start with. All of these papers can be purchased in large sheets, and some are also available in rolls of 10 or 12 sheets.

For the *Gongbi* style you will require meticulous or sized *xuan* paper. You can size it yourself, but it is difficult to obtain an even result and time is more profitably (and pleasurably) spent painting. There are three main qualities of this paper. The best (and thinnest) is called 'cicada' (due to the sound it makes when shaken), followed by 'clearwater' and 'icy' (thickest). Some of these papers have a sparkle on the surface from the sizing. These papers are more expensive than the unsized versions.

Gongbi _____ *Wolf* _____

On the left are small brushes especially for Gongbi work. On the right are wolf-hair brushes for strong lines and strokes.

As more links are created with China, so the availability of unusual papers increases. They are often made using longer fibres, such as mulberry and pineapple, some of which are visible on the surface of the paper. These papers, and others called 'hemp' or 'leather' paper, are thicker and are used for more involved techniques where several layers of pigment or washes are applied to the surface. Many come from Korea and Taiwan, as well as China. They are more expensive to purchase and come in large sheets.

Brushes

Brushes (*bi*) are of many different specifications. The brush is of paramount importance, and evolved from the burnt sticks once used to make marks. Even today there are brushes available that imitate those used in the Ming Dynasty (1368–1644) and earlier. They generally have longer handles and longer fibres. The use of natural fibres is essential to give the resilience and liquid retention required for the fluid and varied strokes. The brushes are classified mainly by their stiffness or softness, and how this affects the marks made on the paper. Compared to Western brushes, the 'belly' of the brush is in a different position, which enables maximum flexibility, recovery and resilience.

Soft brushes are usually made from sheep (or goat) hair, and take time to absorb the liquid. Once fully absorbed, the brush will stay very soft. This means that sheep brushes can become 'tired' if you are painting all day, and it is useful to have a second brush while the first 'rests'. Soft brushes often use rabbit hair,

Papers. L-R: straw, 'Moon Palace', xuan, grass, dyed xuan with gold flecks and long-fibre paper.

or even human hair. Some brush makers provide a service to make a brush from a baby's first haircut – the hair is formed into the brush head and is placed in an ornate holder with the child's name engraved on the handle. Soft brushes are mainly used for flowers, leaves and animals – wherever a soft, wide stroke is required. They are more common in northern China.

Firm brushes are often described as 'wolf' – but this can be a misleading term. They may use ferret, bear or fox hair. They are used for painting branches, stems, trees, calligraphy and anything that requires strength. If you require a good point on the brush stroke, it will be easier to achieve with this type of brush. Stiffer brushes are made of pig bristle, badger or horse hair or tail. They are used primarily for landscape or figure work, where dry, textured strokes are desirable.

Mixed-fibre brushes may have soft hair on the outside and stiffer ones in the centre, or vice versa. The combination of fibres is often varied by artists, who have brushes made to their specification. Some artists find that a favourite brush will do virtually everything, however. The above descriptions are only a guide, and you will only need two or three brushes to start with.

Unusual brushes, including wildcat, cock's feather and a copy of an ancient master's brush.

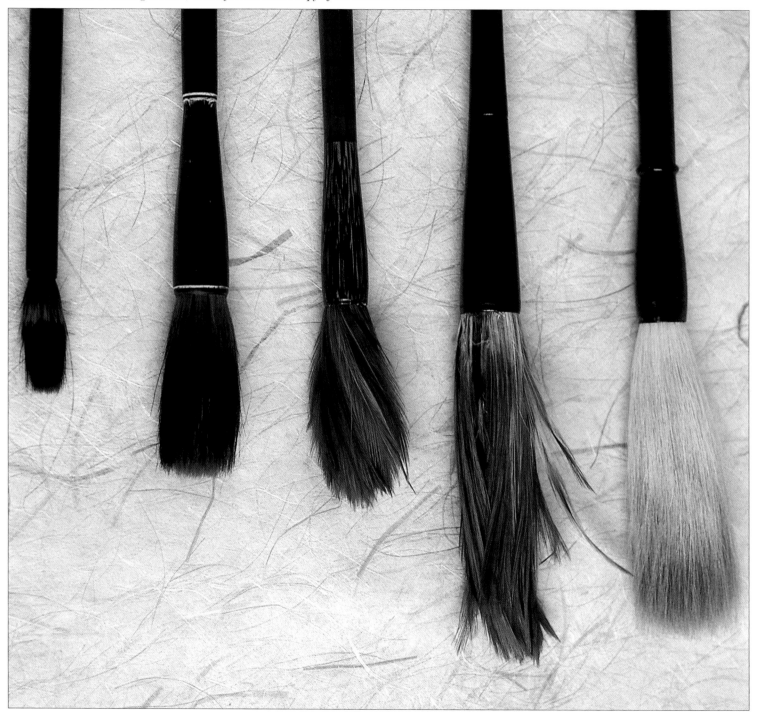

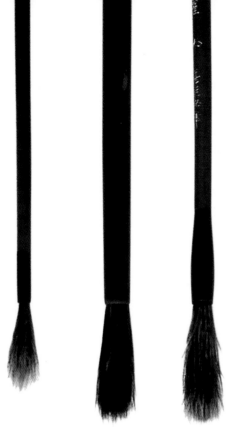

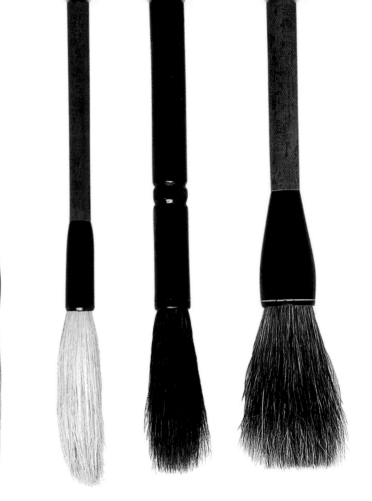

Stiff brushes made of horse hair (mane or tail), badger and pig bristle.

Mixed-hair brushes – usually soft hair on the outside with stiffer hair in the centre.

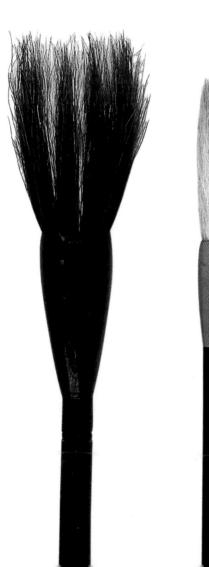

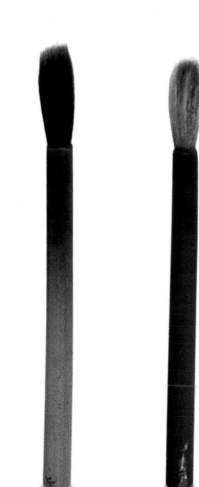

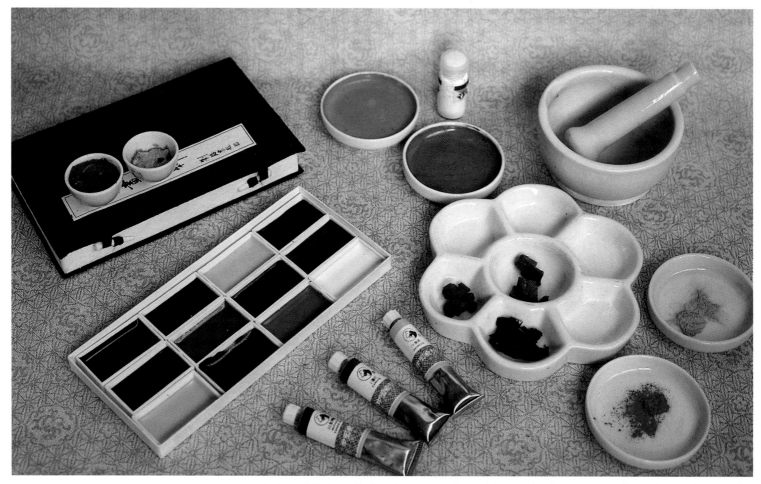

Colours. L-R: box of tubes, Japanese paints, white powder, Japanese set of 12 colours, Chinese tubes and flakes, plus powdered stone colours.

Colours

Colours are obtained from watercolour paints, available in several different forms. Most Western artists are accustomed to tubes or pans, and these can be used for Chinese brush painting. However, Oriental paints have more resin or glue mixed with the paint (often called a binder), and fewer additives, so the paint soaks into the paper and is more static when dry. The paints are divided into two main elements: vegetable (e.g. madder, rouge, rattan, indigo) and mineral (e.g. cinnabar, vermilion, orpiment, azurite, malachite) pigments. The former is transparent, the latter translucent/opaque. When applying one over the other you notice obliteration or exposure of the colour underneath. These qualities can be deliberately exploited.

There are several manufacturers of tube paints, which vary in quality. Sets of Chinese tubes can be purchased at a reasonable price, but are often still in lead tubes. Other options include Chinese flake paints (also called chips or granules), which are placed in a dish or palette and water is added with the brush to release colour. These are very pure pigments. For opaque, mineral colours use tubes, or powder pigments which are mixed with a glue binder and prepared in a pestle and mortar. The colours are strong, but it is sensible to use them only on the face

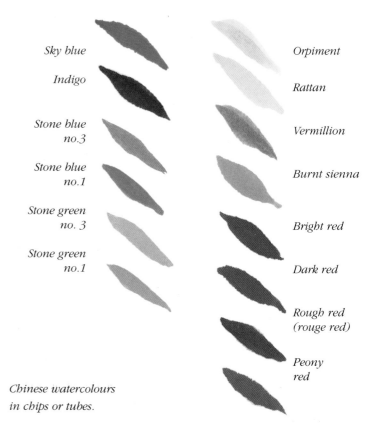

Sky blue

Indigo

Stone blue no.3

Stone blue no.1

Stone green no. 3

Stone green no.1

Orpiment

Rattan

Vermillion

Burnt sienna

Bright red

Dark red

Rough red (rouge red)

Peony red

Chinese watercolours in chips or tubes.

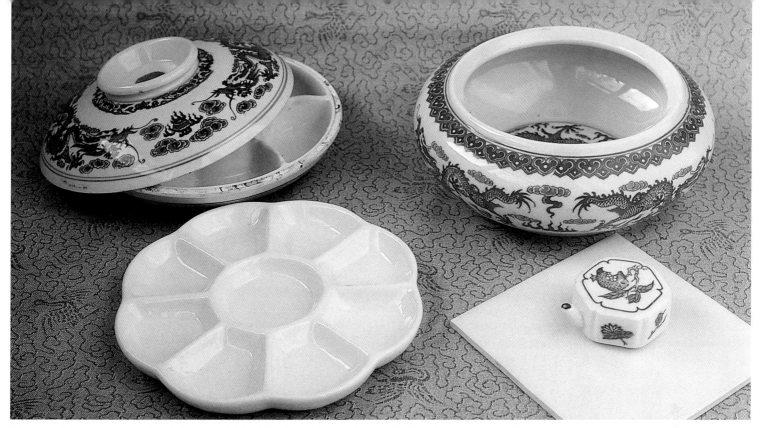

Water containers and palettes. A tile is useful for blending colours. Blue-and-white designs are popular.

of a painting (they are often used on painting silk, where colour may be applied to the back surface as well as the front). The process and expense tends to limit the use of powder pigments for most artists. If modern colours are mixed with glue they are often called pastes.

Japanese pans of paint are very convenient, but are quite expensive compared with the tubes or granules. They are avail-able in a range of good colours, so colour-mixing is less of a problem. Although they have more glue than Western water-colours, some Chinese artists do not like them.

A palette or a white plate is ideal for mixing colours. A white ceramic wall tile is also useful to blend the colours in the brush. The traditional round shape divided into seven or nine sections is called a chrysanthemum palette.

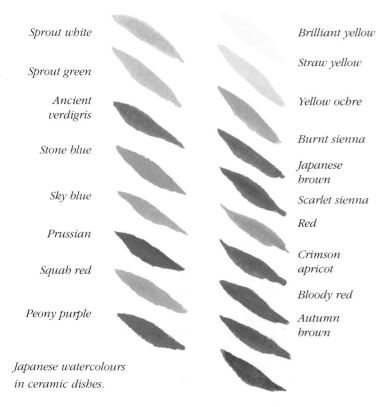

Sprout white

Sprout green

Ancient verdigris

Stone blue

Sky blue

Prussian

Squab red

Peony purple

Brilliant yellow

Straw yellow

Yellow ochre

Burnt sienna

Japanese brown

Scarlet sienna

Red

Crimson apricot

Bloody red

Autumn brown

Japanese watercolours in ceramic dishes.

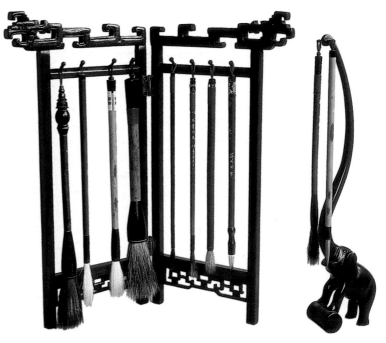

Practical folding brush rack, with a smaller, entertaining one shaped like an elephant.

Other equipment

Felt or a blanket is required to cover the table surface. It can be just under your paper or can cover a larger area. Flannelette or sheeting are not suitable as both are too absorbent. Ordinary felt is also not as good as an old-fashioned piece of felted blanket. Proper painting felts are available in China, but they are very expensive – maybe you could share with a friend, as they are usually at least 1 metre (just over 3 feet) square.

Water pots can be simple glass jars or beautiful objects. The main requirement is for a heavy base – plastic pots overbalance easily, especially when using the edge for wiping the brush. Two or three pots are better than one, allowing at least one for washing out the paint or ink and another to pick up clean water.

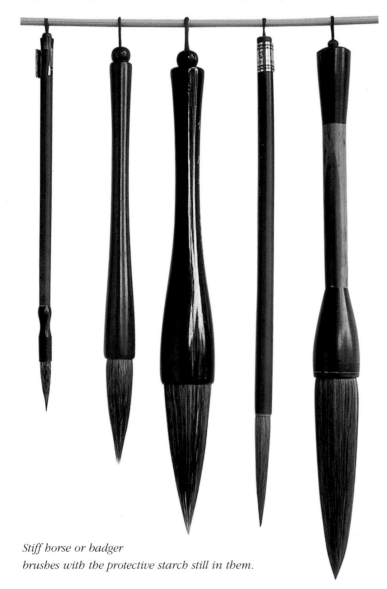

Stiff horse or badger brushes with the protective starch still in them.

Brush rests obtained from an antique shop look very nice, but chopstick rests or other forms of rest are quite adequate. It will help if brushes do not roll sideways, and if possible choose a low rest rather than a high one. Ink stick rests come into the same category – the wet end of the stick must be able to air-dry.

Brush hangers are used in the studio and are often very ornate and well carved. As the glues used to fix the head of the brush into the handle are not always reliable (do not use more than lukewarm water to wash them), it is necessary to air-dry them carefully. Therefore either hang the brushes by the loops provided or leave them on the rest to dry. Do not be tempted to stand them tip upwards in a brush pot.

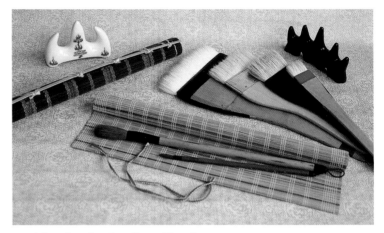

Wash brushes, brush rolls and brush rests.

Paperweights vary in shape, size and weight. Curtain weights or pebbles are suitable, one for each corner. Others are flat bars in metal or wood, placed at the top only, or at both narrow ends of the paper.

Brush rolls or rush/bamboo table mats will allow the air to circulate around stored brushes. Western rolls with pockets may be tidy, but they do not allow the brushes to breathe.

Other beautiful equipment for the 'scholar's desk' may include brush pots (porcelain, ivory or wood), water droppers (for controlling the amount of water dripped onto the ink stone) or any appealing item to encourage mood and effort.

A scholar's desk. An old porcelain ink stone is shown with a round cake of ink. The brushes are copies of ancient versions. The rectangular stone has a quartz band across it and plum-blossom carving. The water dropper and stand are metal.

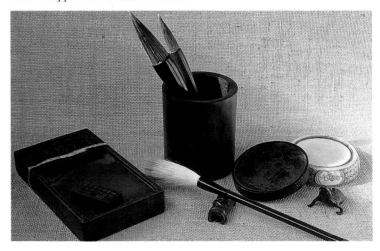

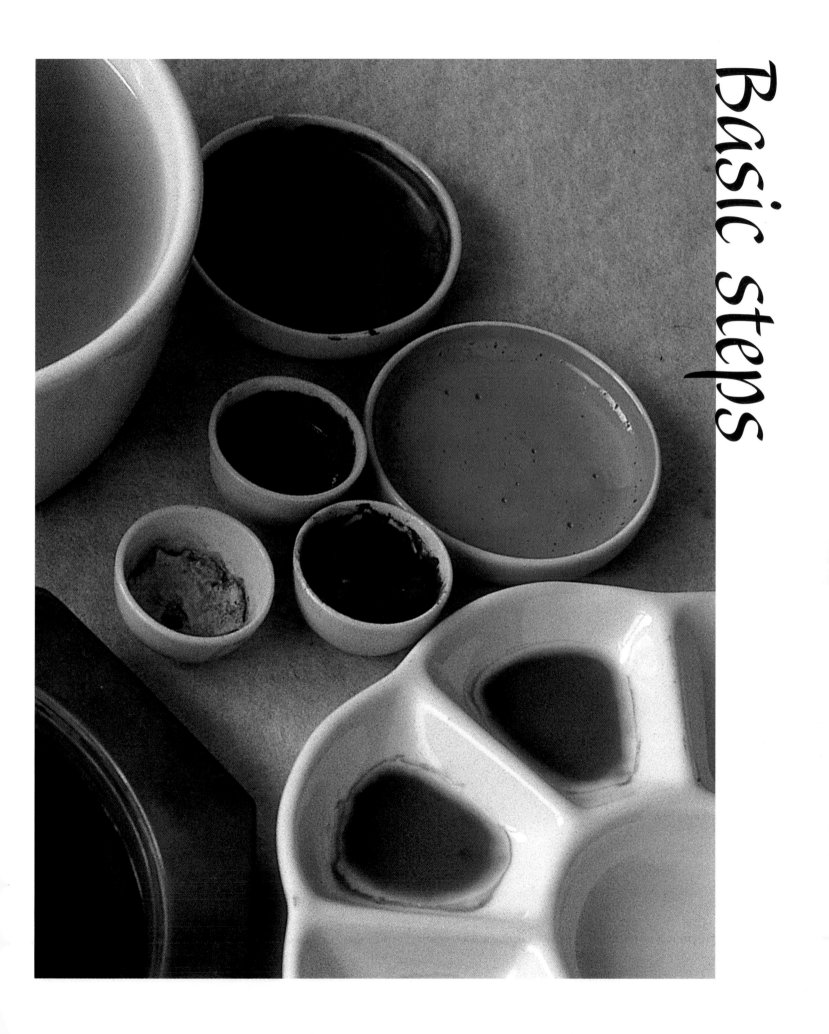

Basic steps

First purchase some equipment – and you can do it gradually. Besides, it is always enjoyable to treat yourself to a 'find' in an art or bric-a-brac store. Try to find some reasonable practice paper, preferably grass paper, which is better than using substitutes for Chinese paper (cheaper too!) Cheaper practice papers will also make it more difficult for you to progress to the more absorbent paper. Essential equipment includes an ink stone (about 100mm/4in square, round or wide) and an ink stick (look for a matt, light stick). Finally, buy two brushes: a fine, firm brush for detail and one other – look for the largest you would feel happy with and buy the next size up. (Most beginners use too small a brush.) If you are in doubt, look for a soft or mixed-fibre brush with the head about 30-40mm (1.5in) long and 8mm (0.3in) in diameter. You will need to soak the brushes in cold or lukewarm water before use to get rid of the stiffening agent used for protection.

Setting up the painting table.

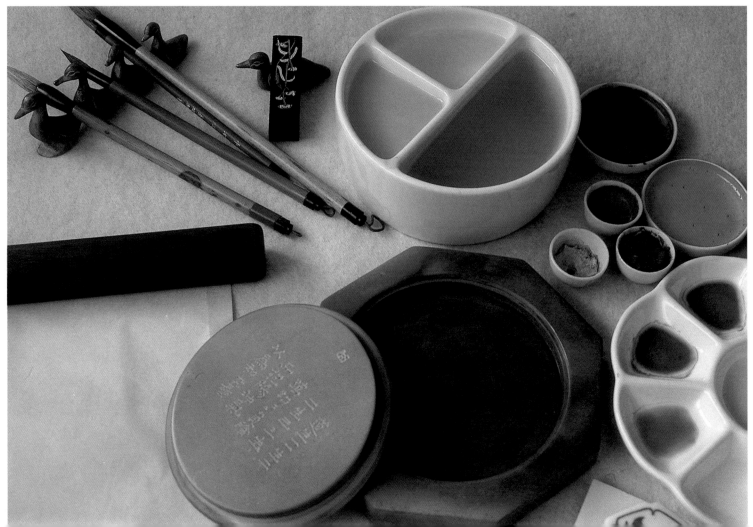

Find an area where you can paint; there must be good light (preferably natural) and a comfortable working height for either standing or sitting. An adjustable chair may help. You should be able to move your arm across the surface without touching it, and with your shoulder held relaxed. The idea is not to lean any part of your brush arm on the table while painting. This position will help you to achieve long, fluid strokes.

Once you have found a suitable spot, set it up by laying out the painting felt or blanket with the paper on top (one sheet at a time or you will have many copies). Place the equipment to the right if you are right-handed, to the left if you are left-handed. This will avoid paint or ink accidentally dropping onto the paper. Add your water pots, pebbles, palette, etc. and you are ready.

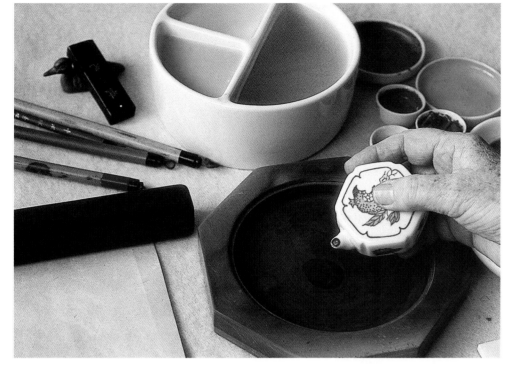

Adding water to the ink stone.

Preparing the paper

This will involve a decision about the size and shape of your painting. Recently, the trend has been for greater use of the square format. Scrolls are now expensive to prepare, and most artists mount their paintings in frames, behind glass.

If the chosen paper is a large sheet (60 x 120cm/24 x 48 in, or 70 x 150cm/27 x 60 in), most Chinese artists will divide it into two, three, four, six or eight pieces. It is sensible to divide the whole sheet at once: painting several works on the same size of paper enables the artist to practise with one amount of space. Find your own preferred scale of painting (this may vary with your mood or the subject), but remember to vary it occasionally – you may be surprised!

The finish of some papers sometimes varies slightly between the two sides. The smooth side is suitable for most work, especially flowers and fruit (as the brush will move more smoothly over the paper), and the rough side for landscape, free-style figures and fluffy animals (the ink and paint will spread more readily on this side). When starting, choose a practice paper such as grass paper. Later, progress to *xuan* paper.

Grinding the ink

Traditionally, this is a restful, thoughtful time, while the artist considers the composition of the work. With a brush, salt spoon or water dropper, add a small amount of water to the flat surface of the ink stone. A teaspoonful of ink will take about 200 revolutions to get to black – so do not add too much. Hold the stick upright, with your index finger on the top and the other fingers and thumb to each of the wide sides. Gently move the stick in a

clockwise direction and watch how the ink changes. It will become oily-looking, and later should have some dry patches on the stone. This is the sign that it is reaching 'burnt ink' – dry, black ink. Various shades can be made by diluting the black ink with water. Grind the ink to black to release all the resin; as water is added, the resin is diluted. By controlling the 'wet and dry' qualities, as well as the 'shades', 'colours of ink' (burnt, thick, heavy, pale and clear) can de developed. Practice this dilution, as the variation of ink tones will enhance your work.

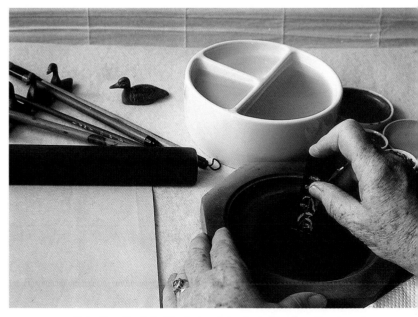

Grinding the ink. The paper is protected by the other hand.

Brush loading and control

Try not to twist the brush when loading it, especially if you are a watercolourist, as this will make the natural fibres open out and the brush will be less controllable (think of your brush as similar to your own hair). If the ink stone, water pot and palette all have defined edges, use them to wipe excess ink off the brush. There will probably be some liquid inside the hollow bamboo handle. To control the ink, use a tissue or rag to remove

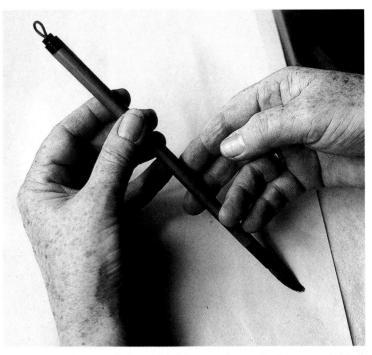

Showing 'balanced hold' – two fingers in front, two behind.

Vertical brush hold – for strong strokes.

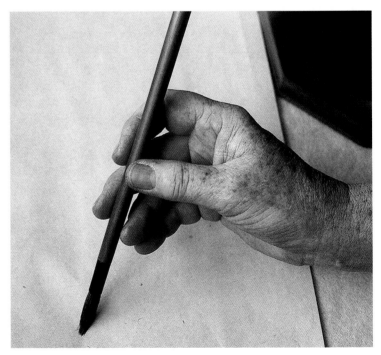

Oblique brush hold for soft, larger strokes.

the excess from the heel of the brush rather than the tip. It will help to have a piece of cloth or tissue by the side of the palette to dry the brush after rinsing, or to adjust the liquid level, moving the brush in one direction.

Chinese brush painting is often admired because very few strokes are used to depict a scene or a subject, while at the same time showing the 'essence' or 'spirit' of it. Therefore, each mark made with the brush is important. The space left on the paper is also important.

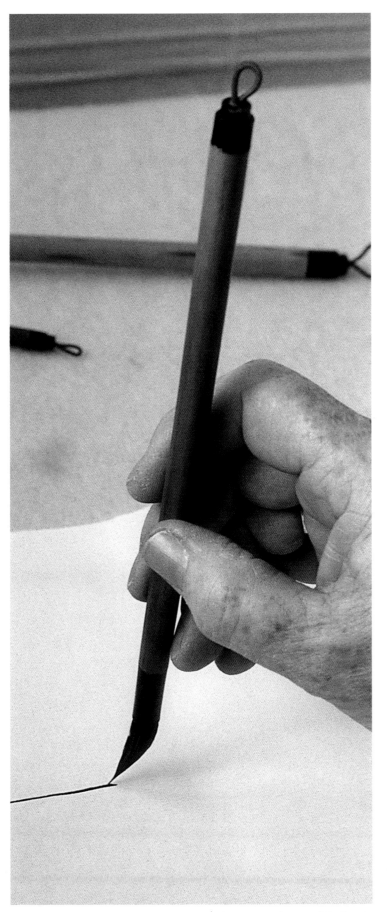

Fine line using the tip of the brush.

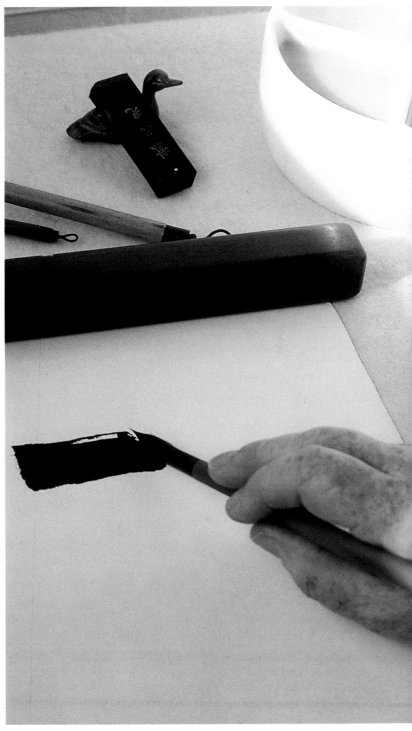

Wide stroke using the side of the brush.

The first strokes

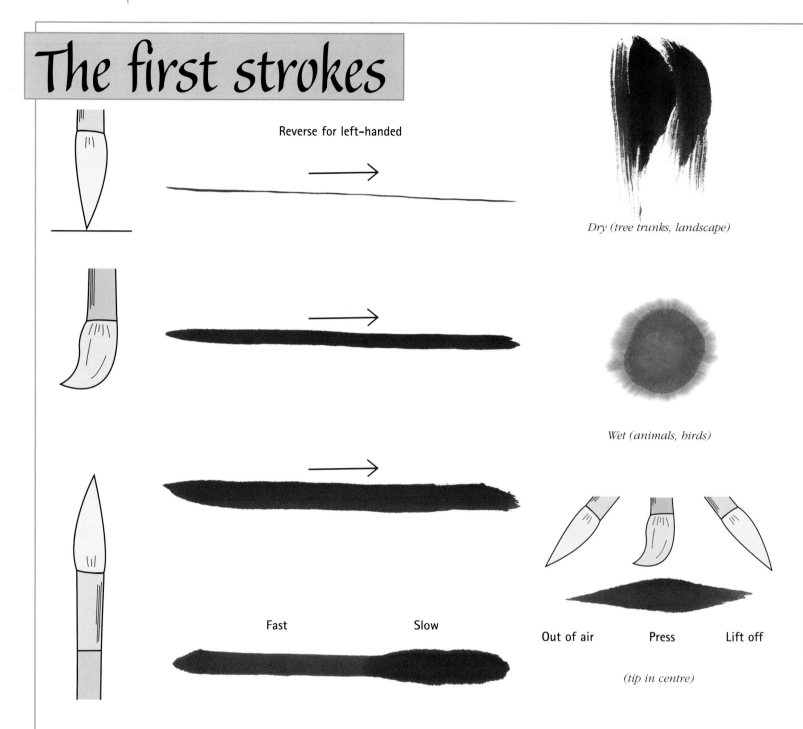

Reverse for left-handed

Dry (tree trunks, landscape)

Wet (animals, birds)

Fast Slow

Out of air Press Lift off

(tip in centre)

1 Use the first strokes to obtain an idea of the pressure, speed and control necessary to produce the effect you want. Initially, try to imagine the brush as a pendulum – use a dry brush and gently touch the paper at the bottom of the swing. Load your brush with ink and repeat the stroke. You should have a bamboo leaf! Stroke the brush in different directions, both towards you and away, to the left and the right. Remember to keep your arm clear of the table surface, but make sure that your shoulder is relaxed, not held stiffly. Next, repeat the action, but lift the brush vertically up from the paper and notice that the end of the stroke is rounded. If you lower the brush onto the paper vertically and then complete the 'pendulum', you will have a 'nail-head' stroke. Whichever stroke you carry out, try to do it in a flowing movement, without hesitation. Carry out the stroke slowly, and then repeat it quickly, and see the difference. If you find the liquid is insufficient in your brush during a stroke, slow down, and hopefully you will be able to complete the stroke. Experiment on different papers. If you find one too absorbent, make the stroke quicker or lighter, or leave that particular paper until you have more experience.

2 Try using the ink very wet and painting a soft, rounded shape. Next wipe the brush on the ink stone or palette, then use a tissue or cloth to adjust the amount of liquid. Think of a gnarled, twisted branch and push your brush along it. Notice how there are white lines in the stroke when it is really dry. This is called 'flying white'. Look back at the rounded, wet shape and notice how far the ink has spread, and how fuzzy the edges are.

3 Once you have practised some of these strokes you will be ready to place them together, initially to create leaves and petals of two strokes and then to create other subjects. You will also be ready to introduce colour.

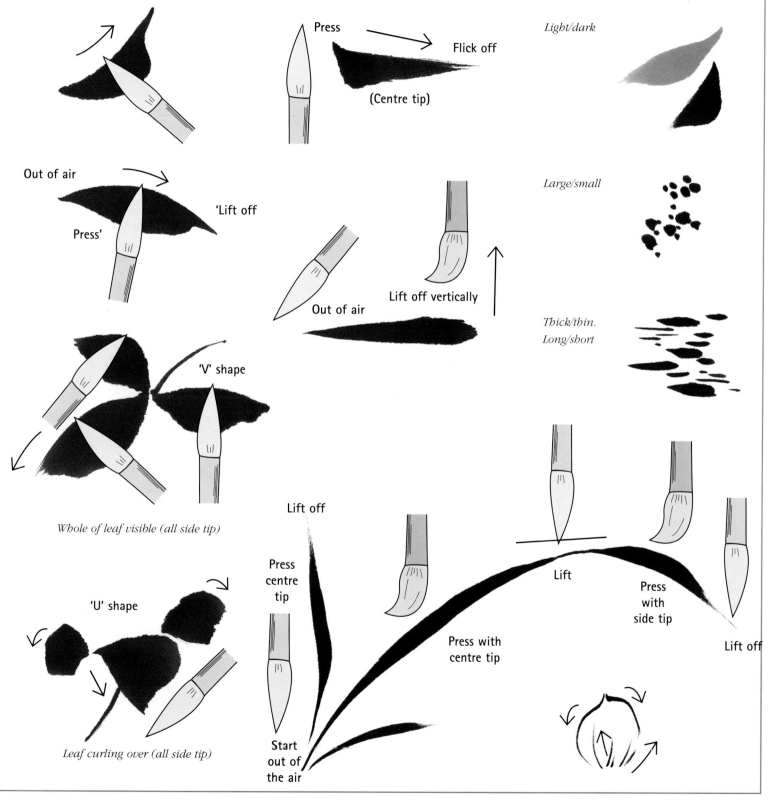

Press
Flick off
(Centre tip)

Light/dark

Out of air
'Lift off
Press'

Large/small

Out of air
Lift off vertically

Thick/thin.
Long/short

'V' shape

Whole of leaf visible (all side tip)

'U' shape

Leaf curling over (all side tip)

Lift off
Press centre tip
Start out of the air

Press with centre tip
Lift

Press with side tip
Lift off

Colour loading

Colour adds a great deal of interest to a painting. Load a main colour onto the brush and then tip it with a darker colour, or load three or four colours one after the other. As with most things, do not overdo this or the effect will be 'muddy'. Use a palette or a white wall tile to mix and blend the colours in the brush. You will actually obtain more colours than you load, because they will blend together. Try to achieve 'large and small' amounts of colour – the basic principles still apply.

It is useless carefully to load the brush if you do not use it in the correct manner. Avoid making a pool of colour in a palette and then using it blandly – a small amount of another colour on the tip of the brush will help. When you load the brush tip, make sure that it is placed where it is needed – in the centre of a flower, for instance, to indicate the trumpet-like structure, or to the point of a petal to give a darker edge to the flower. If you wish to paint a very thick branch, dip the brush in ink and place the tip on the outer edge of the trunk of the tree as the example.

As with all of the mixing and design, too much of something will be as boring as too little. So a little simplicity or plainness will emphasise the ornate. Do not, therefore, use too many colours, or too much variation.

Hints and tips

If a painting is not going well, and you normally sit to paint, try standing for the next effort, or vice versa. Or, if you normally use a firm brush, try a softer version. Try a different scale as well. If you do not obtain the results you would like, then change the subject to one that you are more confident with, or if all of these fail, go and do something else! It is probable that you will succeed next time. Tell yourself 'It is not my day for this subject' rather than saying 'I cannot do it'.

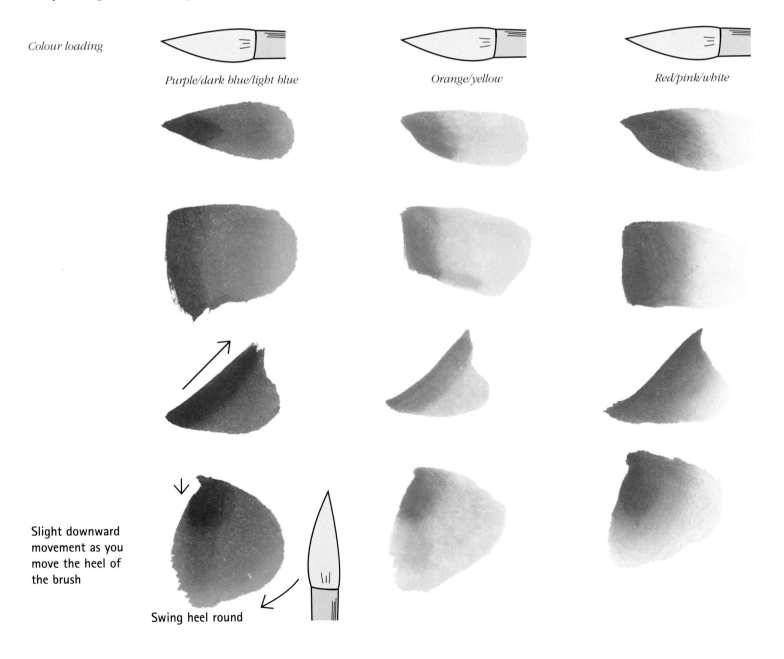

Colour loading

Purple/dark blue/light blue *Orange/yellow* *Red/pink/white*

Slight downward movement as you move the heel of the brush

Swing heel round

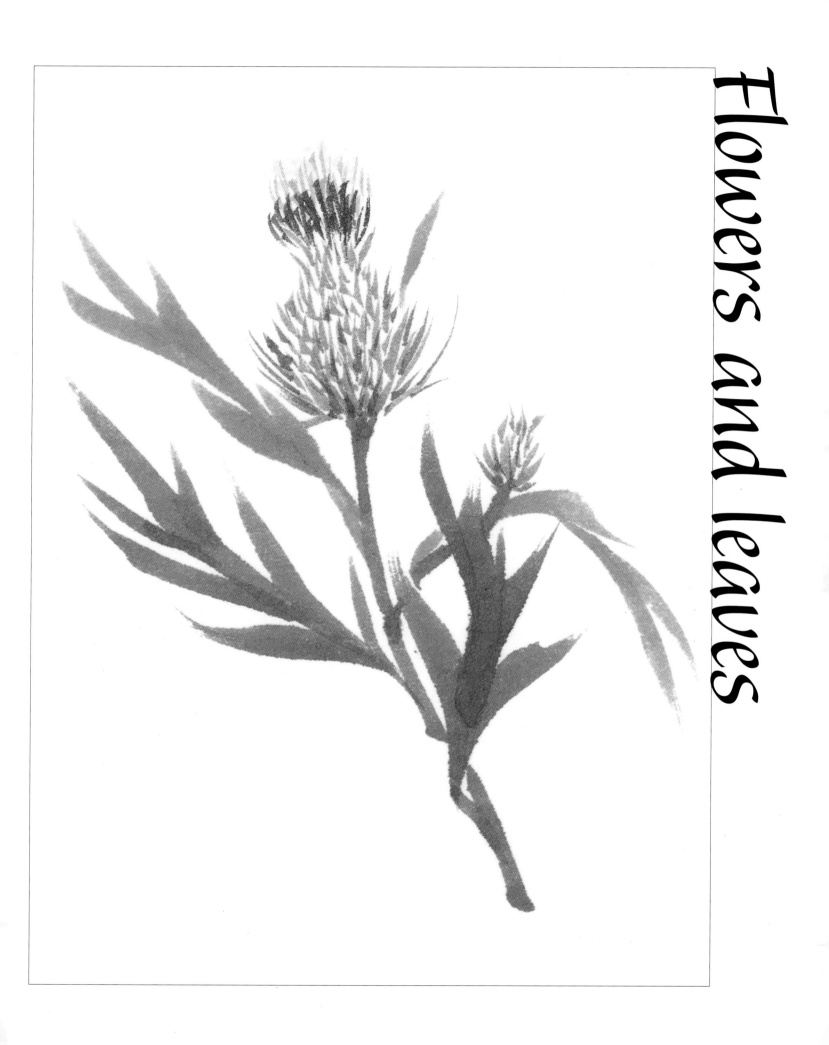

Flowers and leaves

Flowers and leaves

Given the importance of nature to the Chinese, it is hardly surprising that flowers feature in many of their paintings. Yet in the beginning, the majority of paintings were of figures and landscapes. Gradually this changed. Flowers symbolise many qualities, such as loyalty or filial obedience (bamboo), piety or perfection (orchid), unworldly scholar or retirement (chrysanthemum) and fortitude or strength (plum). These are known as the 'Four Gentlemen'. In many books you will find alternative descriptions – it depends how the scholar artists of a particular period wished to portray the plant and the 'political statement' they wished to make.

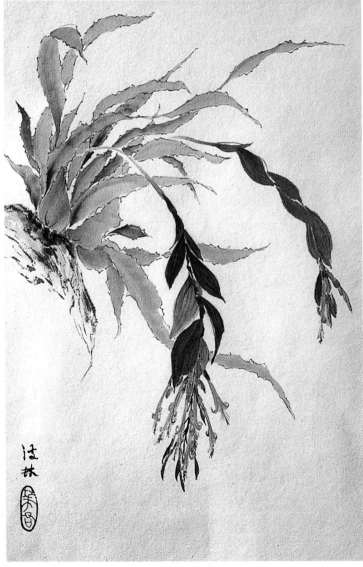

Bilbergia.

Plants were linked with the seasons, too: peony for spring, the lotus for summer, chrysanthemum for autumn and plum for winter. The plum was also linked with bamboo and pine in a group called the 'Three Friends in Winter'. The rose, on the other hand, was associated with all of the seasons. Other paintings can feature the 'Four Friends of Flowers' – swallow, oriole, bee and butterfly. With these traditions to prompt the artist, there is plenty of inspiration (see the lists of symbolic meanings on page 44).

These facets of Chinese brush painting add an enormous amount of interest for the enthusiastic painter. But there is no reason why other flowers or objects cannot be portrayed in this style of painting. In fact, it is exciting to work out the techniques and colour loading. In Western art it is usual to paint with the flower and leaves in front of you. Many Chinese artists study the flower in great detail, maybe over a long period of time, and finally go into the studio to transfer observations and feelings onto the paper from their memories. If you are uncertain about working in this way, after picking the plant, place the flower behind you so that you do not 'paint every petal and leaf', but rather paint the 'essence' of your subject. This also applies to photographs and books. Above all, there should be a balance of elements. Remember to leave some space around the subject, and to 'manage the white'. This is one reason why you need to use the paper at the final size of the painting, rather than cut it down afterwards.

Flowers

Flowers painted in the Chinese style are extremely popular in the West. They can be painted in a variety of styles, both simple and complex. Extreme simplicity means that each stroke must be very good, while the *Gongbi*, or meticulous, style needs excellent, fine brushwork. Some artists specialise in one style or the other, and academies in China teach the *Gongbi* style as part of

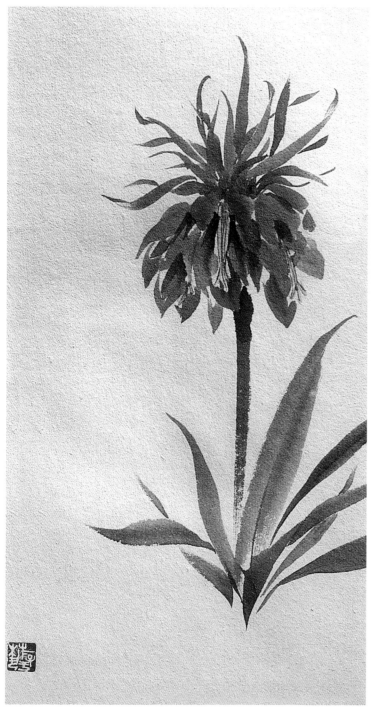

Fritillaria.

viewer. Once you are more experienced, the order is immaterial. (If working on a new subject, however, you may need to revert to this original order of painting.) Details such as veins, stamens and thorns can be added at an appropriate time. Veins need to be painted while the leaves are still slightly damp, as they form part of the plant surface. Stamens and thorns can be added when the painting is dry, as they are separate elements. Ensure that these are not evenly spaced.

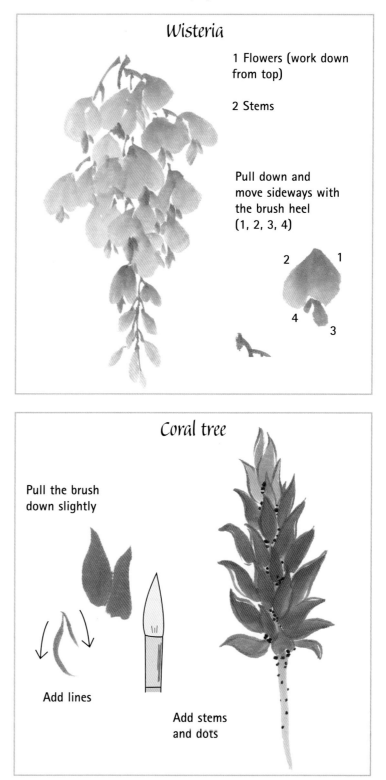

Wisteria

1 Flowers (work down from top)

2 Stems

Pull down and move sideways with the brush heel (1, 2, 3, 4)

Coral tree

Pull the brush down slightly

Add lines

Add stems and dots

a long and rigorous training, leading to better skills in the *Xieyi* style. In the West, due to the lack of academy-trained teachers and Western preferences (as well as patience levels!), the process is often the other way round.

When painting flowers it is best (for a beginner) to paint the petals first. This will allow concentration on the angles and distribution of the flower heads. Follow these with the leaves, and lastly add the stems. This technique will prevent a very common mistake, which is to show too much stem, or not to leave spaces for the leaves and flowers to pass between the stems and the

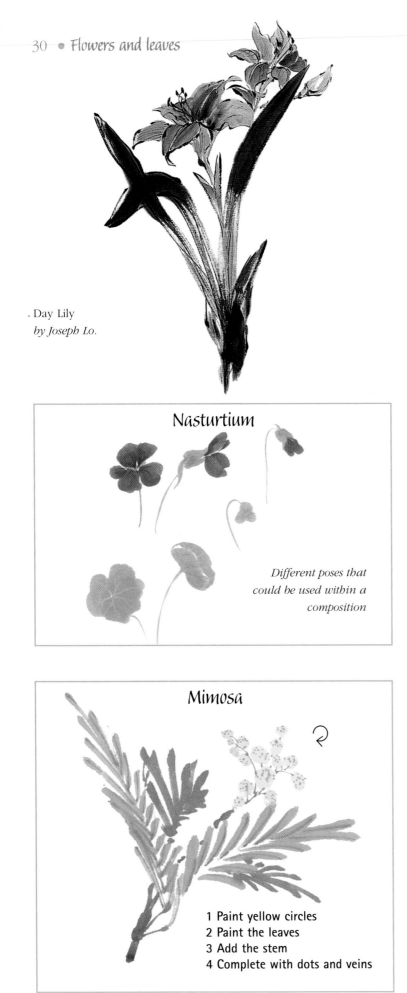

. Day Lily
by Joseph Lo.

Some flowers can be formed with very few strokes, others need several to form each individual flower head or petal. Many flowers will require the tip of the brush (therefore a vertical brush), others the side (an oblique brush). A composition should contain buds, fully open flowers and perhaps some seed heads, too. Arrange the flower heads so that they face in different directions, and if you add insects, make sure that the 'bees have space to fly', and do not give the composition a regular shape.

If painting the flower in the solid-stroke technique, as in the day lily, turn the tip of the brush towards the outer edge of the petal. Complete the flower and leaves, then add a few light lines to clarify the edges of the petals and leaves only where needed.

Narcissi, also called 'water fairies', should be painted in loose outline first, then add the colour and free-style leaves.

Nasturtium

Different poses that could be used within a composition

Laburnum

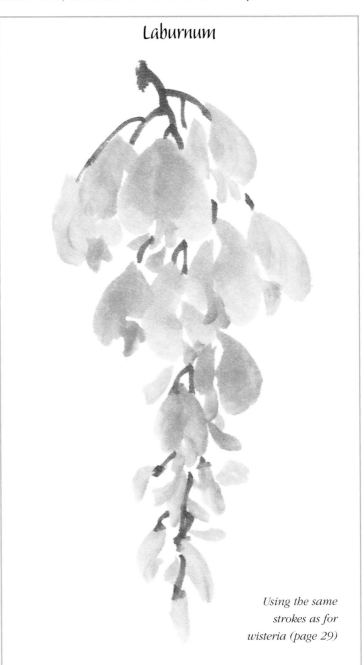

Using the same strokes as for wisteria (page 29)

Mimosa

1 Paint yellow circles
2 Paint the leaves
3 Add the stem
4 Complete with dots and veins

Narcissi by Joseph Lo.

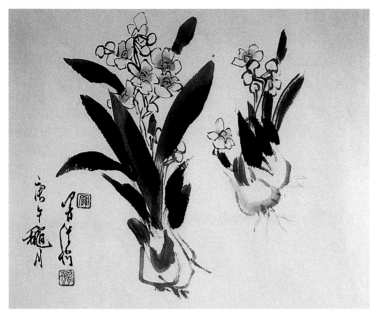

In a very detailed flower, the leaves may be sketchy. Be careful not to paint every leaf, or to have too many crossing points. Avoid even lengths, or retaining the same width of leaf for too long. Your brush should be used both sideways and up on the tip to achieve variation in the leaves' appearance. Leaves need to be painted in a lively fashion; they are often robust and make the flower appear more fragile or dainty. Even long, curving leaves (especially bamboo leaves) should have a 'backbone' – they should not hang limp like 'wet washing' or a bunch of bananas.

Like flowers, leaves can be formed from one, two or several strokes. The first two usually need to be formed from a 'centre tip brush' or 'side tip brush'. If a second stroke is added to the first, you can choose whether to place both tips to the centre of the leaf, both tips to the outer edges, or one tip to the centre and one to the outer edge. Experiment with these different methods

Leaves

Leaves can help in identifying a flower. They give a sense of strength and support and often provide a balance between light and dark, flexible or stiff. When viewed as *yin* and *yang*, the flowers are feminine and the leaves masculine. The lotus below shows this very well. The flower is protected by the leaf.

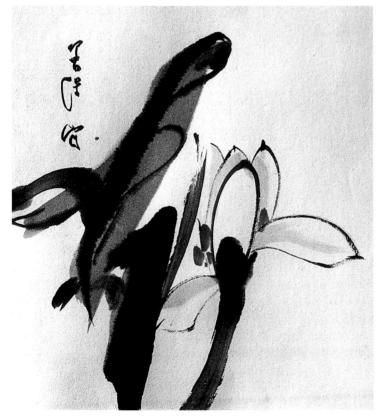

Lotus by Joseph Lo.

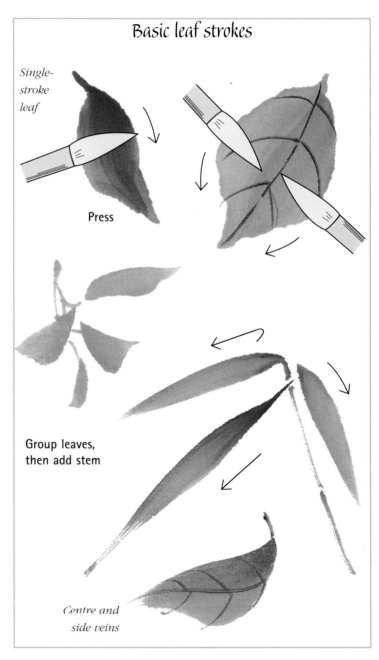

Basic leaf strokes

Single-stroke leaf

Press

Group leaves, then add stem

Centre and side veins

Basic leaf strokes

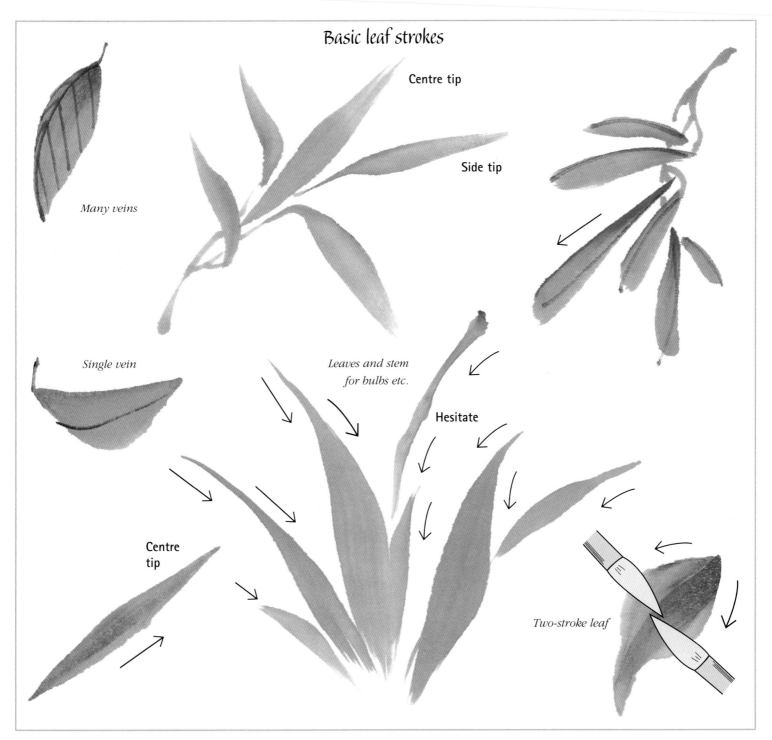

Many veins

Centre tip

Side tip

Single vein

Leaves and stem for bulbs etc.

Hesitate

Centre tip

Two-stroke leaf

of forming the leaf to see which you prefer and which would best suit the subject. Above all, do not allow leaves to be boring – vary the length and width of the brush strokes, as well as the space between the leaves. Ensure that there is colour variation in the leaves, either ink or pigment. It is usual to paint leaves with the brush travelling from stem to tip. However, sometimes it is better to do it in the opposite direction: when the tip of the leaf is very important and the plant grows in a clump formation, you do not want to emphasise the base of the plant. The way in which the brush is placed on the paper and then lifted off affects the results. Lift the brush vertically to achieve a rounded end.

In Chinese brush painting, it is not usual to show the ground level. As in other categories of subject, the important element is the attitude of the plant – it must look as if it is growing, and therefore clustered at the base in a believable fashion. This is easier to achieve by starting at the tip of the leaf and pulling the brush downwards and off the paper gradually, which gives a poorly defined base to the leaf and adds to the illusion of a clump of leaves gathered together in a three-dimensional way. There are also times when you will need to 'show the tip' or 'hide the tip' of the strokes you make. A cluster of bamboo leaves is a good example of this, where some leaves are shown towards the viewer.

Stems and branches

Although they must look capable of holding up the flower head and leaves, stems and branches should not be painted too thickly or look clumsy. An upright brush, with a stroke pushing away from you is best – it is easier to make the stroke thinner than to control thin-to-thick stems. However, there are times when you may want to paint the stem from flower to root, such as lilies, gladioli and amaryllis. Remember that plants grow unevenly, depending on the seasons and weather conditions. The lateral growths will be affected by the seasons as well, so the length of the stems between the nodes must vary. A hesitation in the line of painting represents growth variations, especially on shrubs and trees, but make sure that they are not evenly spaced. Additional nodes, shoots, lichen and thorns can be added later, very often as *mi* dots, which are traditionally used to express such things. The branches must be at sensible angles to the main trunk or stem. Try to imagine a flow of energy from the main plant that extends to every twig. If the angles are too acute, then the sap will not reach the ends.

Veins, stamens and pollen dots

The veins are part of the surface texture of the leaf and should therefore be painted while the leaf is still damp (but not wet). Use a brush with a good point, and paint from the stem to the tip of the leaf. Veins are often painted in ink or dark colours, but it is sometimes more in keeping with the plant to paint light veins. Use lines, not dots, to represent veins – think again of the energy reaching the edges of each leaf. Use suitable patterns – are the veins straight or curved, are there many or few? Once again, do not paint them too accurately, simply enough to give them character. Above all, they need to have *qi*. As you gain experience, the veins should become more free and stylish.

Veins on flower petals are usually a darker version of the petal colour, or white. They can be painted from the stem to the tip, but are often not taken all the way, just far enough to suggest some pleating of the fragile structure of the petal. They should not all be the same length or distance apart. You may also wish to paint some short veins or markings from the outer edge of the petals, for example, on irises. These marks are carried out with a nail-head stroke, a definite starting point and then into the air.

The same stroke is used for painting stamens, which should be done when the paint or ink is almost dry, as they form a separate part of the flower. Again, do not paint them evenly in length or spacing.

Pollen dots are, as their name suggests, varying sizes of dots. On some of the colourful, more ornate, flowers they are frequently painted with yellow and white mixed together to give the opaqueness to show up against the dramatic flower colour. The peony is a good example of this.

Some plants have aerial roots, such as the Meilin orchid. These can be painted with a fine brush, but they can also be shown by splitting the fibres of a larger brush and using only a couple of brush strokes. Vary the amount that the split brush comes into contact with the paper to avoid several parallel lines.

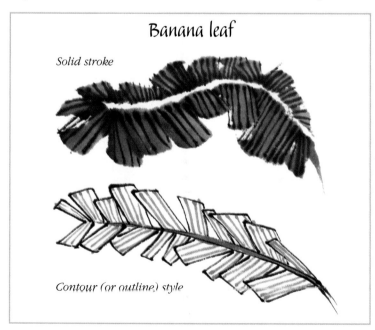

Banana leaf

Solid stroke

Contour (or outline) style

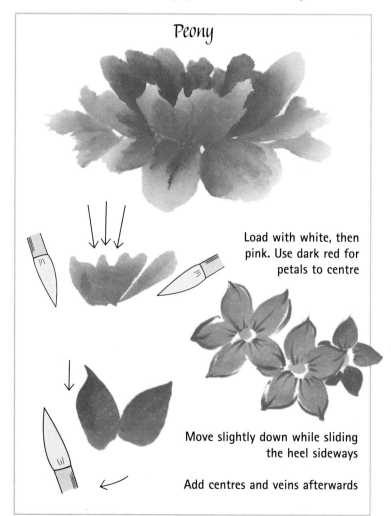

Peony

Load with white, then pink. Use dark red for petals to centre

Move slightly down while sliding the heel sideways

Add centres and veins afterwards

The 'Four Gentlemen'

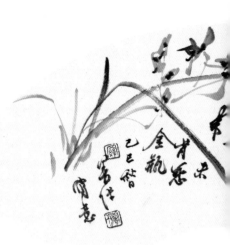

1 Painting the 'Four Gentlemen' featured in the Introduction requires practice. For the plum blossom, paint the bronze Ku beaker first. Then add the branches with a dry brush to obtain some 'flying white', followed by the flowers. The flowers are shown here in mineral green, which is sometimes substituted for white flowers. The calligraphy is written in ancient style.

2 The bamboo is the most difficult, and this example shows a powerful red bamboo (although bamboo is traditionally painted in black ink, it is sometimes red, the colour of happiness and celebration). The stems were painted first in this instance, followed by the leaves and details. It is the leaves that most painters have problems with. They must have substance and must not 'dangle' from the stems.

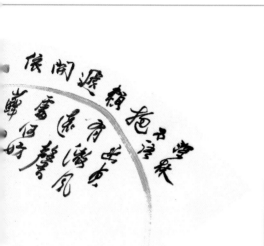

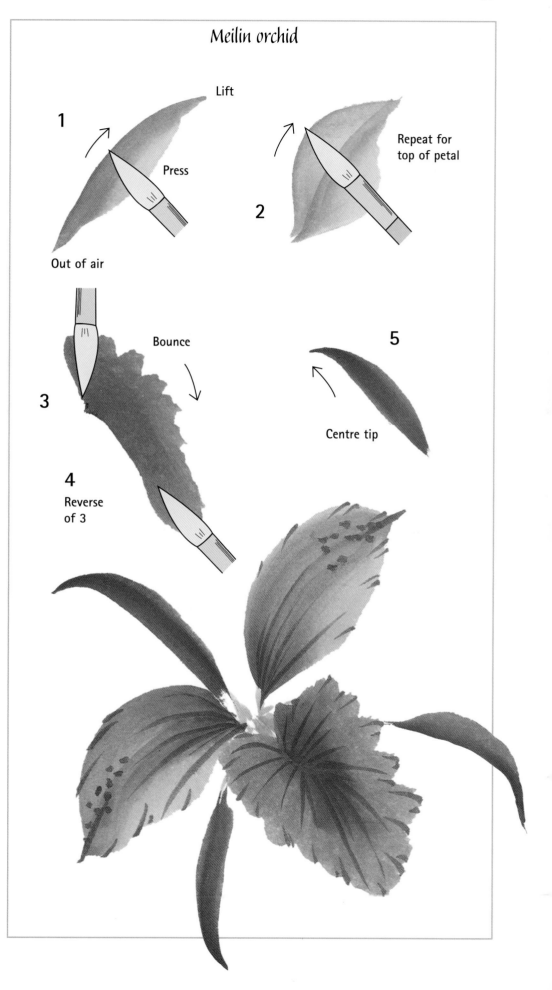

Meilin orchid

1 Lift
Press
Out of air

2 Repeat for top of petal

3 Bounce

4 Reverse of 3

5 Centre tip

3 The orchid example is shown in a flat-fan format by Joseph Lo, together with some calligraphy. Notice how it is made into a 'whole' painting, and how interesting the ink tones are.

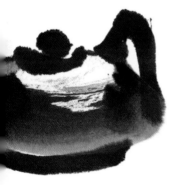

4 Chrysanthemums are often linked with utensils, especially those to do with tea-making. This flower is used to symbolise scholarly retirement. The flowers were painted first, then the leaves and the stems. The veins were added last. Here, the delicate, thin petals of the flower contrast with the roundness of the tea pot. The 'flying white' on the pot adds an essential dimension to it.

Pontedaria

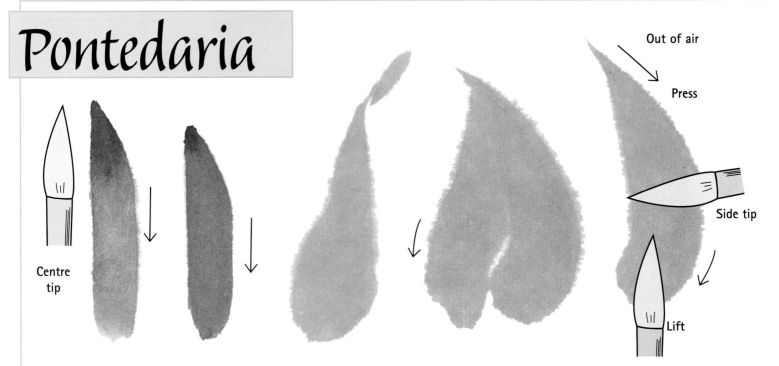

1 Load a medium brush with blue pigment and tip the point of the brush into a dark blue or purple. With the brush held tip to the top, pull it downwards as you touch the paper.

3 Using green pigment and a larger brush, paint the leaves in two strokes, from the tip to the base. Vary the width of the stroke to make the leaves twist and turn. Vary the colour of the leaves. To achieve the curved base, paint the stroke from the tip with the handle towards you, then swing the brush handle through 90° while lifting the brush off the paper.

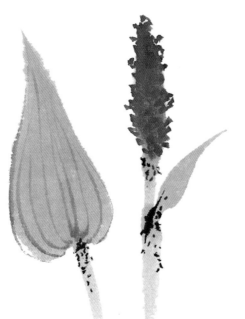

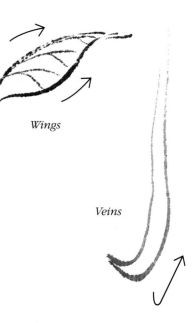

2 Add some dots with a vertical brush, leaving space between the strokes. Load with a dark blue and add more dots. Imagine four small petals forming a flower – place these to the outer edge of the flower spike.

4 Pull the stem strokes from the flowers or leaves in a downwards direction with an upright brush. With light ink, define the shape of the leaves with veins and paint a few dots on the stems where shown. Add the dragonfly with a fine brush and dry ink, making it rest lightly, but securely, on the leaf. You can add some very light colour to the wings to suggest the shimmer of the transparent material. Paint the insect facing the scene.

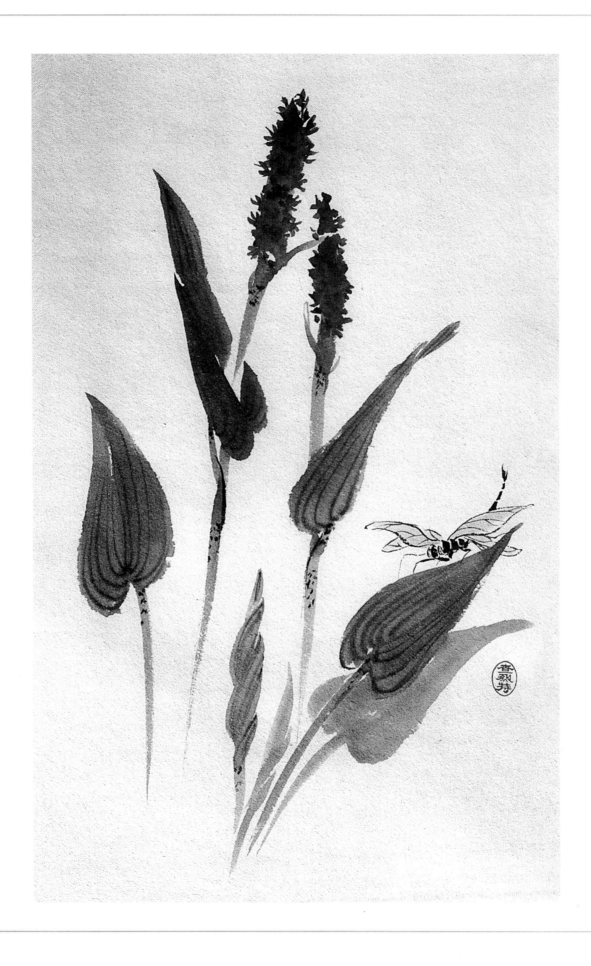

Thistle

Flick off the paper

1 Using a small brush, and with varying green/blue paint, carry out small flicking strokes from the flower head outwards (place the brush down and flick it off into the air). Form the rounded shape. Add purple strokes for the flower, with yellow pollen dots on the top.

Side tip

2 Use the blue/green colour again and work from the stem outwards to the tip of the leaf. Paint the leaves using several uneven strokes with an upright brush, linking the strokes to get the required shapes.

Stem centre tip

3 Lastly, add the stems with firm, pushing strokes, painting from the base towards the flower.

Alstromeria

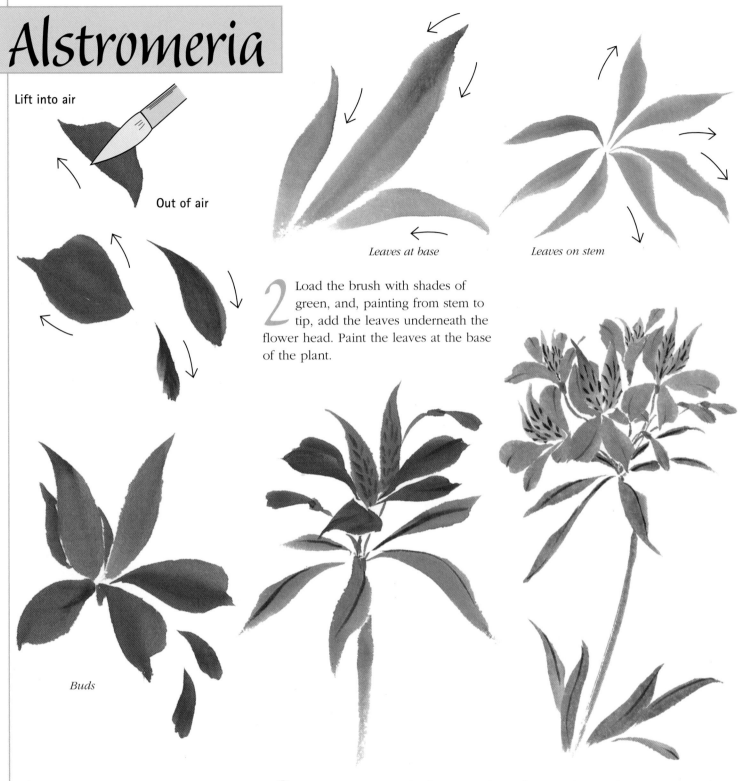

Lift into air

Out of air

Leaves at base

Leaves on stem

Buds

2 Load the brush with shades of green, and, painting from stem to tip, add the leaves underneath the flower head. Paint the leaves at the base of the plant.

1 Using bright red and orange, form each petal with one or two strokes, working from the centre of the flower to the outer edge. There are four ordinary petals and two thinner, upward petals in a lighter colour. Add a few buds below the flowers.

3 Add thin stems to the flowers and the markings on the thin petals. Lastly, paint the main stem downwards, from the underside of the flower head. To make the stem appear as if it goes behind the lower leaves, pull the brush off the paper early.

If you wish to make a more complex composition of these flowers, paint the flower heads at different levels and vary the sizes of the overall flower heads (maybe having fewer open flowers and more buds). Paint in veins on the leaves (if desired).

Bindweed

1 With light ink and a fine brush, paint the outline of the flowers and buds, making them face in different directions. Do not allow the lines to be continuous, but leave some gaps. Try to show the flowing edges of the flowers. The flowers are 'divided' into five segments. Vary the stroke thickness too.

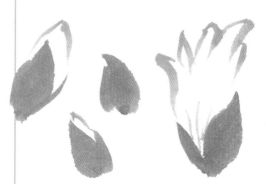

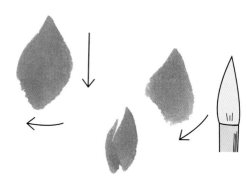

2 Using a medium brush and light-brown paint, place the calyxes of the buds in position. Use the tip of the brush to the top and make a petal shape. Show unopened buds with green added to the brush. Paint one larger and one smaller stroke to suggest that the buds will open soon.

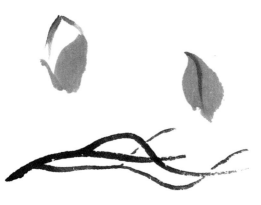

3 Mix some darker ink and add a few strokes to give greater emphasis to the flowers – again, do not make the lines continuous. Add the centres. These trumpet-shaped flowers tilt to face the sun at midday.

4 The leaves are painted in two strokes, working from the heart-shaped top of the leaves to the tip. Angle the brush handle away from you as you touch the paper, sweep the brush round through 90° to get the rounded shape, and pull the brush towards the end of the leaf, gradually lifting it from the paper to achieve the long tip. Add veins to the leaves (stem to tip) and calyx (tip to stem).

Pull

1

2

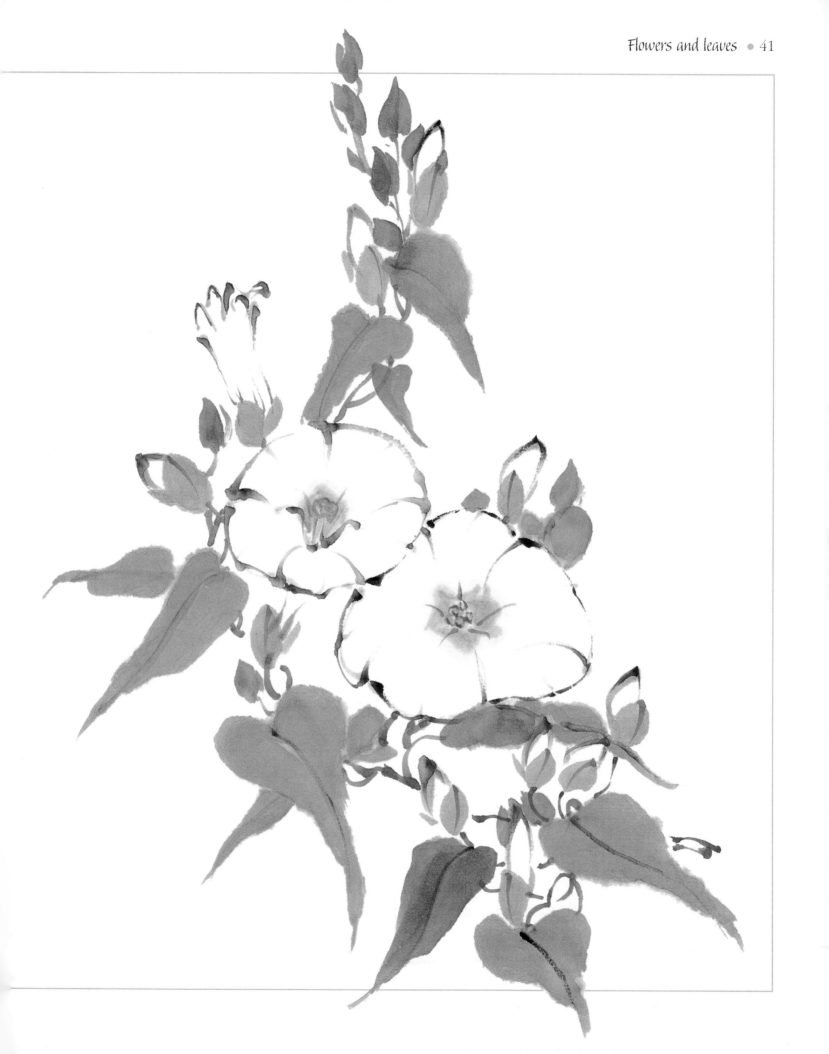

Bougainvillea

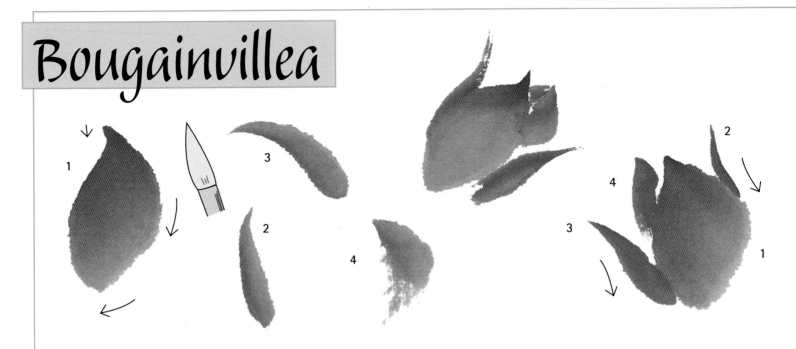

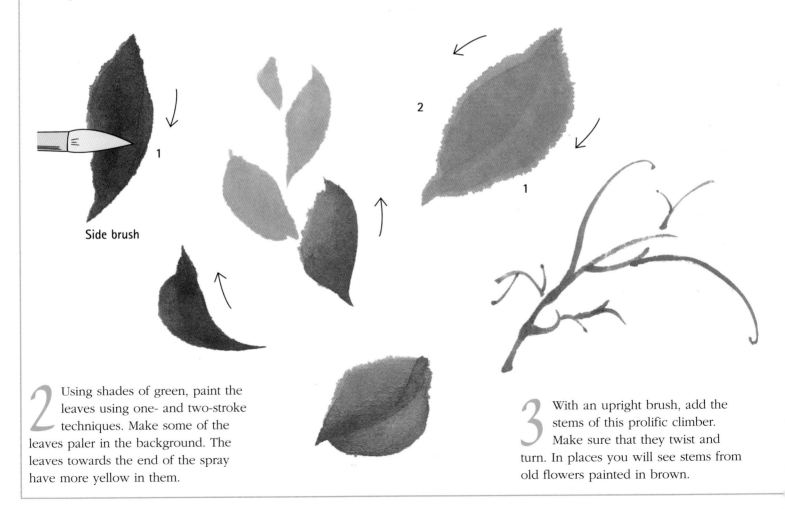

1 Load the brush with either an orange/red combination or pink and purple, as in this example. Use a wide petal stroke for the nearest petal, with the tip of the brush to the top. Paint two narrow petals to each side of the first and another, partly seen petal at the back. Looking down on this variety, you will see it is rectangular in plan, with the side petals tucking inside the outer ones. Ensure that the flowers face in different directions.

Side brush

2 Using shades of green, paint the leaves using one- and two-stroke techniques. Make some of the leaves paler in the background. The leaves towards the end of the spray have more yellow in them.

3 With an upright brush, add the stems of this prolific climber. Make sure that they twist and turn. In places you will see stems from old flowers painted in brown.

4 The 'flowers' are bracts, and you can add green veins to them – I have only painted them on the front and side petals. Use ink veins on the green leaves for contrast; notice that they have more strokes. On the paler leaves in the background, use light brown for their veins, or leave them plain to increase the depth of view.

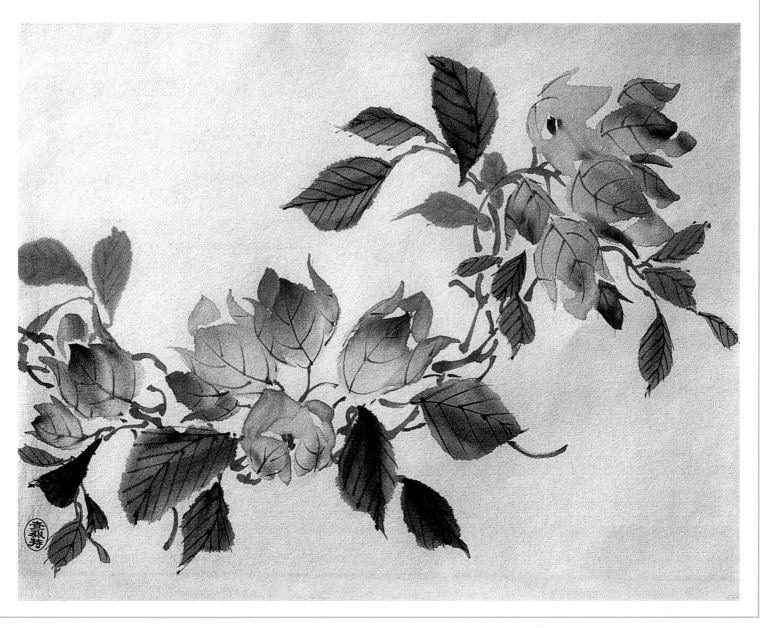

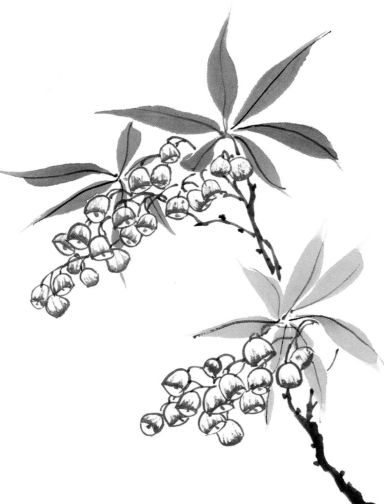

Enkianthus

The Enkianthus is best painted with an outline style for the flowers, in order to emphasise their delicate bunches. By contrast the leaves need to be lively and in rosettes.

As you are painting, make sure that you do not use too pale a colour – on absorbent paper your strokes will dry back by approximately 30 per cent.

Combination paintings

The following show the traditional symbolic combinations of flowers with other subjects.

Almond blossom/court ladies

Aster, azalea or jasmine/butterflies

Bell flower or myrtle/god of wealth

Camellia/dragonflies

Cherry/young people

Chrysanthemum/crabs, dragon, young girls

Convolvulous or rose/humming bird

Fungi/old man or young boys

Gardenia or mallow/swifts

Iris, magnolia or rose/bees

Lotus/ducks

Mallow or olive/geese

Millet or rice/quails or partridges

Myrtle or pear/officials in robes

Narcissus/fairies

Oleander/birds or insects

Peach/bridal procession

Peony/phoenix, peacock or pheasant

Pine, plum/stork or white crane

Pomegranate/children playing

Poppy/white bear

Willow/swallow

Seasonal flowers

There is also a flower for each month.

Spring (tree peony)		Lotus	July
Plum blossom	January	Pear	August
Peach blossom	February	Mallow	September
Peony	March	**Autumn** (chrysanthemum)	
Cherry/apricot	April	Chrysanthemum	October
Summer (lotus)		Gardenia	November
Magnolia	May	**Winter** (poppy/plum blossom)	
Pomegranate	June	Poppy	December

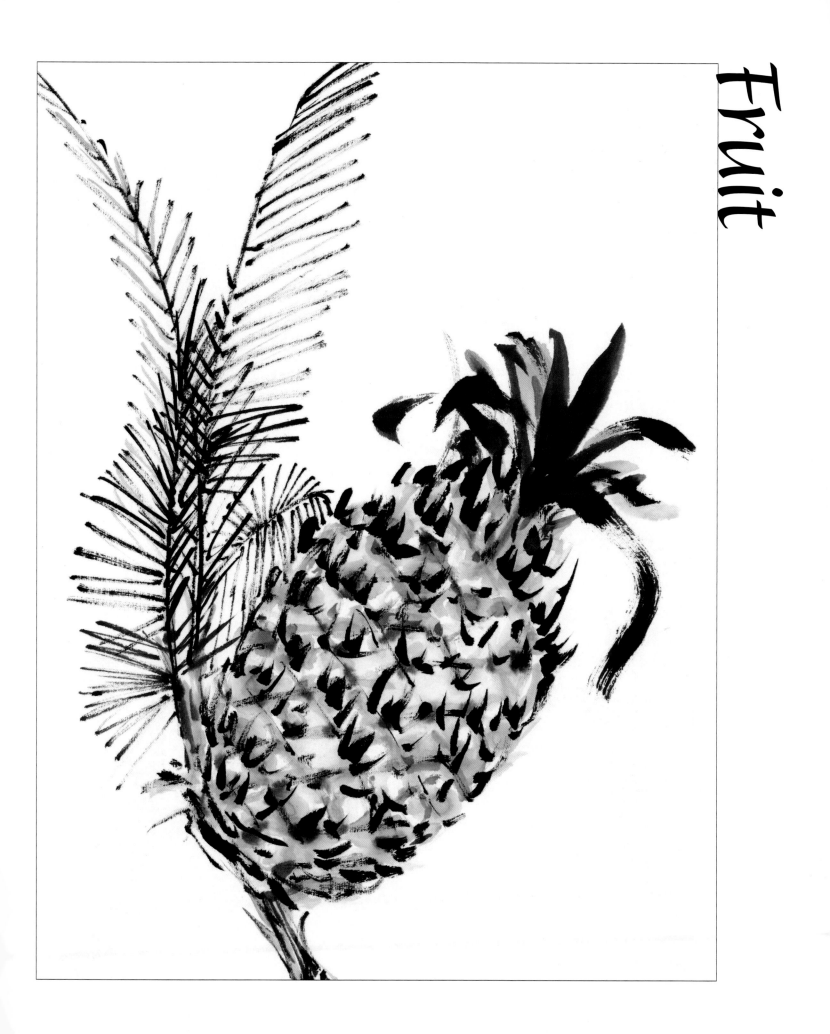

Fruit

Fruit

Fruit in Chinese brush painting can be shown in two ways. It is often illustrated growing, usually in profusion, or as part of a 'still-life' composition, with other subjects, such as fish. It is symbolic of wealth and harvest and is used for good wishes: persimmons are popular at the time of the Chinese New Year festival, for example. The nature of fruits like gourds, which have many seeds, is seen as having 'many blessings', which can refer to wealth or children.

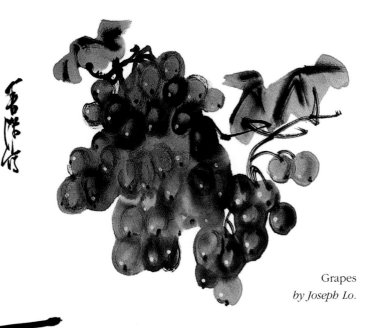

Grapes
by Joseph Lo.

Lychees
by Joseph Lo.

However the artist chooses to show the fruit (this may be in detail, including such things as highlights to show the gloss on a bunch of grapes, or small, soft dots to indicate the pitted nature of strawberries), the composition of the picture is still of overriding importance. There is usually (particularly in some of the older paintings) some indication of the passage of time, with withered, or even deteriorating, fruit that has attracted insects. Often the fruit will be combined with antique plates or bowls, or with well-crafted baskets.

Many fruits can be symbolic of certain months of the year: plums, apricots, peaches and cherries are associated with the first four months, for example. In the West, oranges were given as presents to children at Christmas, and this was also a tradition in southern China, where the fruit was eaten on the second day of the New Year festivities.

Some fruit can be confused with vegetables, as the Chinese, particularly in the south, preserve vegetables in syrup and eat them as a dessert. Many vegetables have similar meanings to fruit.

Tips for painting fruit

When painting fruit, brush loading is important. As with flowers, it is better to paint the fruit, the leaves and then the stems. Load the brush with colour, tipping it with a darker shade. Place the point into the imaginary centre of the fruit and move the heel around the outside of the fruit. This will result in a fruit that is darker in the centre. Alternatively, you can push the tip of the brush around the outer edge to achieve a darker rim.

For fruit with a recess at the top and bottom, it will be necessary to use two strokes to describe the shape, one in each direction, but overlapping slightly. Always watch the tip of the brush and the shape being made on the paper, adjusting the pressure as you paint. Adjust the handle of the brush; begin with it pointing away from you, using the side of the brush to gain the width in the centre, and finish with the handle towards you. If you have a hole in the middle you have used the brush tip in the centre of the stroke all of the time. Vary the colours to suggest fruit ripening within the composition.

Complex fruits, such as the pomegranate, are painted one stage at a time. The seeds are shown first, the 'shell' is wrapped around them, and the stem and leaves are painted last. The symbolism of 'many seeds – much wealth' is also important. If the fruit is painted in detail, make the leaves and stem less pronounced.

Simple berries

1 To paint simple berries, such as whitebeam, load a firm brush with varying shades of green, pink and red. Always remember that fruit appears at various degrees of ripeness. Think about how groups of berries are arranged on the plant. Blackcurrants, for example. form a wide, horizontal-shaped group.

3 Always paint from the stem to the tip of the leaf. Load a firm brush with brown or red-brown paint and use a vertical hold. Push the brush firmly to create the main stem, and then the smaller stalks that join the berries to the stem.

4 Lastly, paint closely grouped veins on the leaves in darker green. Some leaves, especially the paler ones, should be left without veins to accentuate the 3D effect. A small black dot on the end of the berries will add liveliness to the groups of hanging berries.

Notice the differences between the previous example and these other, similar, berries. Just a few changes in detail and growth portray a different shrub and berry. Chinese brush painting should make you more observant, and will add to your enjoyment of nature.

2 Using a softer brush and two strokes, paint the leaves, making sure that the point of the brush goes to the centre each time.

Strawberries

It is necessary to combine painting techniques for the strawberry. There is a dimple in the top of the fruit, but a rapid slimming of the fruit towards the base.

1 Use two strokes with a soft brush – the right-handed should carry out the right-hand stroke first – lifting off the brush at the bottom of the fruit to give a narrow line. Paint the second, left-hand stroke, following the arrows carefully, and lift off again to keep the narrow, slightly pointed, base. If the fruit is on a plate or in a bowl, the whole fruit will not be visible. Vary the sizes and the shades to show different amounts of ripeness.

2 Before the pigment is dry, add some dark-red or -green dots to part of the berry to hint at the dimpled surface. Remember the principles sparse and dense, large and small. With bright green, add the calyx and stem at the top.

3 The bowl can be Oriental in design or a familiar part of your home. Here, a shallowturquoise bowl has been added, and then, after the cream, an Oriental porcelain spoon to eat it with!

Dragon fruit

Dragon fruits, which originated in Asia (especially Vietnam), have become more widely available since 1996. They are the fruit of the torch cactus (Cereus family, so called because they were used for torches when dried), and are either a glorious cerise or purple. When they are cut open and chilled they have a beautiful, delicate flavour. They can be enjoyed like a melon, leaving just the thin skin.

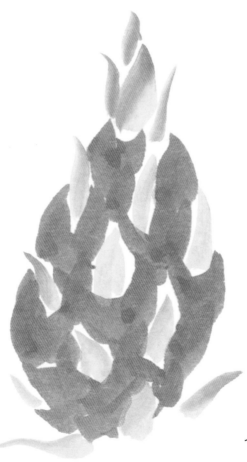

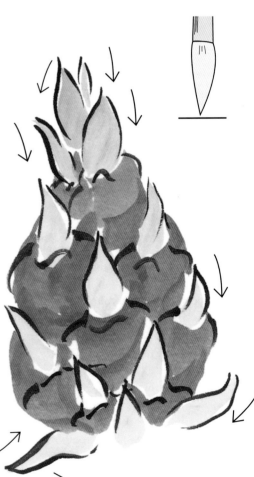

1 When painting this fruit, load your brush with green and yellow and, starting from the top of the 'leaves', pull the brush downwards. It may be helpful to use a fingernail to indent the surface of the paper with an oval shape to mark the outer limit of the fruit before beginning.

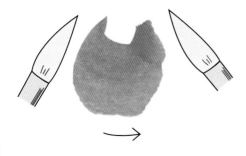

2 Mix a cerise colour (Japanese paints are useful here) and tip the brush in darker red. With the tip of the brush to the top, perform 'scoop' strokes around the green tips. Try to achieve the right shape at this point – the later inkwork will help.

3 Once the fruit is complete and the paint has become damp (rather than wet), use a small brush loaded with ink to paint in the markings as shown. Where the leaf tilts outwards, it forms a dimple in the skin. Use lively strokes.

4 Add the stem. You can either paint it on the cactus or place it in a bowl, with a fruit cut open. The inner flesh has tiny seeds in it (similar to frog spawn), but you do not 'feel' them when eating it – the texture is rather like sorbet.

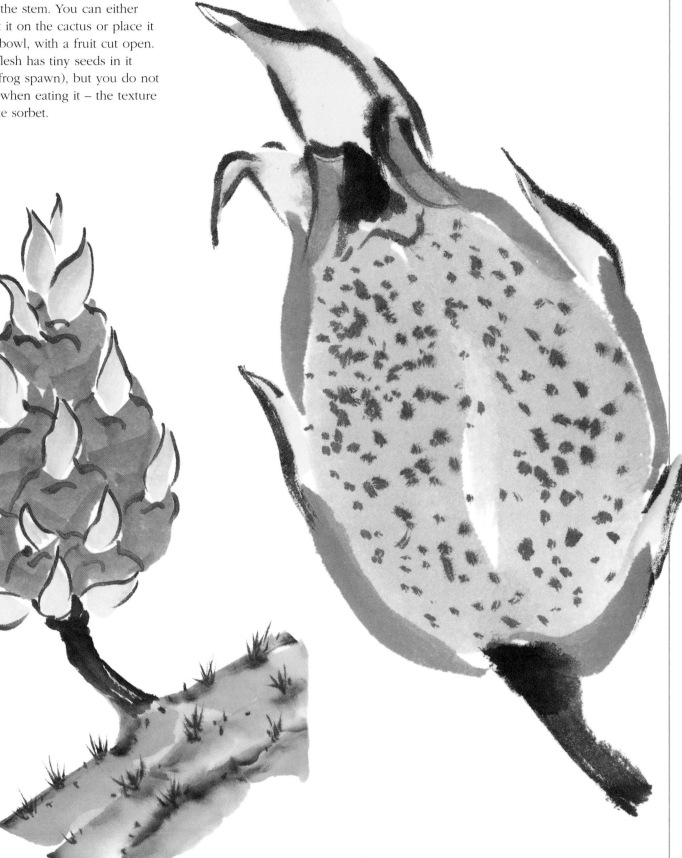

Rice plant

The rice plant is the staple diet of many people in China.

It can also make an attractive and vibrant painting.

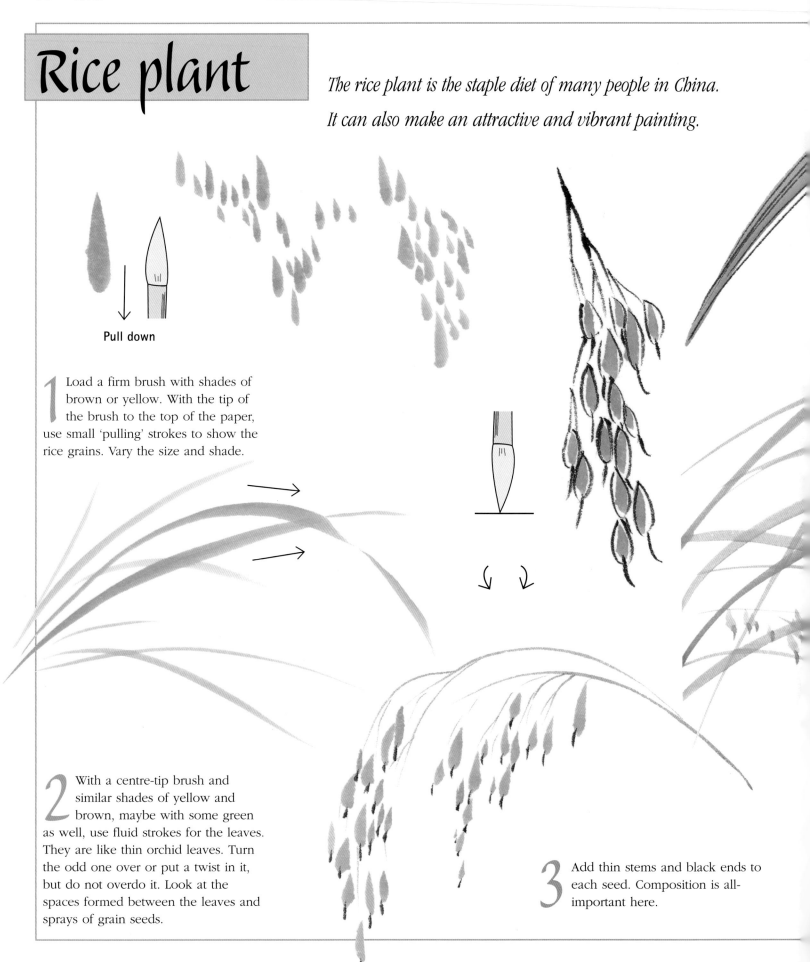

Pull down

1 Load a firm brush with shades of brown or yellow. With the tip of the brush to the top of the paper, use small 'pulling' strokes to show the rice grains. Vary the size and shade.

2 With a centre-tip brush and similar shades of yellow and brown, maybe with some green as well, use fluid strokes for the leaves. They are like thin orchid leaves. Turn the odd one over or put a twist in it, but do not overdo it. Look at the spaces formed between the leaves and sprays of grain seeds.

3 Add thin stems and black ends to each seed. Composition is all-important here.

Complex fruit

Alternative way of painting

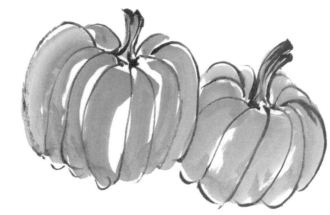

Even complex fruit, such as the pineapple, can be painted with these techniques, as in the following example. It is important to achieve variation between the ink and colour, and to be sparing with detail, relying on the viewer's imagination. Here, the size of the fruit is contrasted with the delicate leaf.

Gourds and pumpkins are also popular, mainly because they are linked with the idea of harvest and wealth.

Vegetables

Vegetables feature in several types of Chinese brush painting. They are often painted in the meticulous style, along with other food items or ancient vessels, especially bronze. All manner of vegetables are shown, including some that seem very Western.

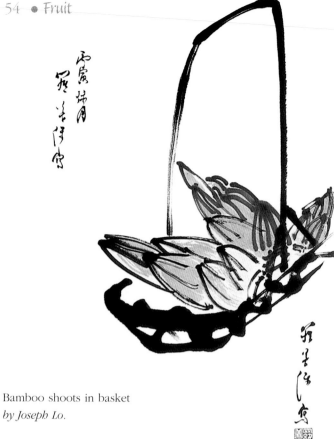

Bamboo shoots in basket
by Joseph Lo.

Notice in the composition of radishes how the colour, density and grouping changes. It is both pleasing and exciting. The thin roots add direction and provide a thin contrast to the rounded shape of the vegetable.

The dense, black strokes of the container of bamboo shoots contrast with the outline and modelling lines of the fruit. Notice the angle and position of the subject, together with the amount of space around two sides.

The Chinese leaves also have space and a great variation in ink shades, wetness and dryness. The bright red of the tops of the root crop contrast beautifully with the subtle ink colours.

Chinese leaves *and* Root
vegetable *by Joseph Lo.*

Many items grown by Chinese farmers were dried and stored for the winter months, and families were dependent on such staple crops. All vegetables are included, such as Chinese leaves, root crops, mushrooms, water chestnuts and other varieties that are so Oriental that it is difficult to find names for them. Vegetable paintings often seem quite esoteric, and they are not as popular in the West or so revered.

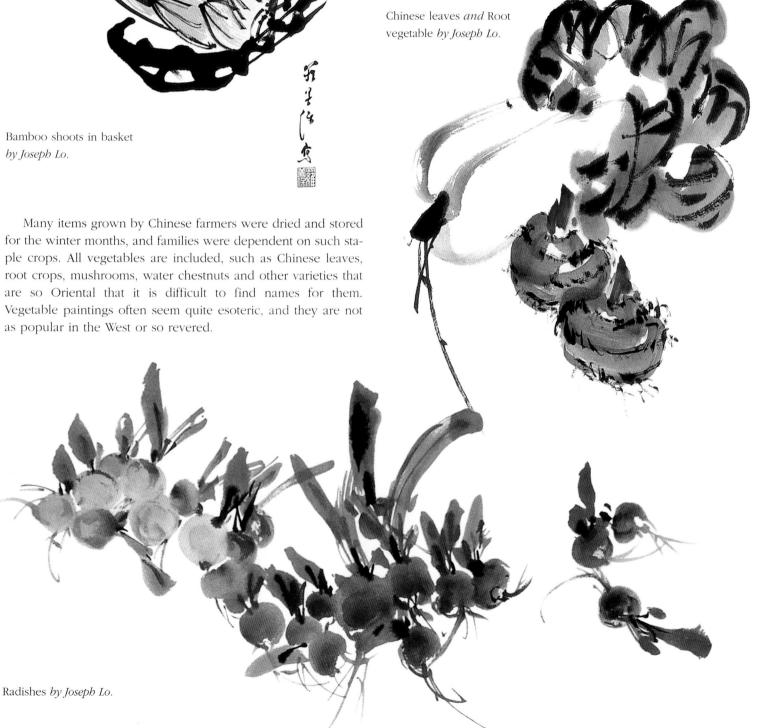

Radishes *by Joseph Lo.*

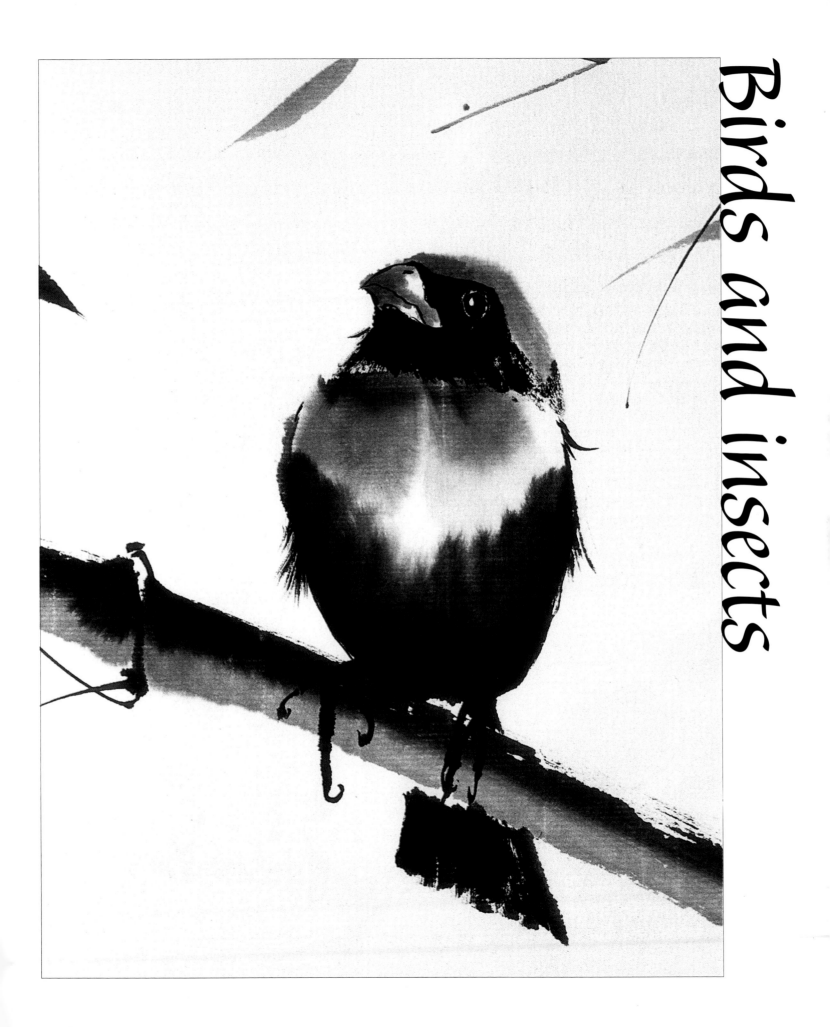

Birds

Many Chinese brush paintings seen in the West include birds or butterflies. Of course, they can also be painted as separate subjects on their own. Like flowers, fauna have various symbolic meanings associated with them. Swallows are painted for someone taking exams, a pair of ducks for a wedding, butterflies for beauty and a cicada for longevity – there are many more.

Sometimes birds are painted in a humorous way, showing (or maybe accentuating) their particular character. The brushwork may seem careless, but it is the overall effect that is most important. The direction of the glance is often very pronounced, giving a small 'happening' within the painting. The bird will probably give the viewer a strong idea of its next meal!

Before you start painting, consider the essential points of the subject that make it special, and decide which elements of the character of the bird you wish to emphasise. Should the bird (or insect) be ferocious, meek, noisy or comical?

There are also traditional links between plants and birds: peonies with either a peacock or a pheasant; a lotus with a duck; a willow with a swallow; a millet with quails or partridge; and pine with crane. These traditions can often suggest a painting to an artist. (See also the list on page 44.)

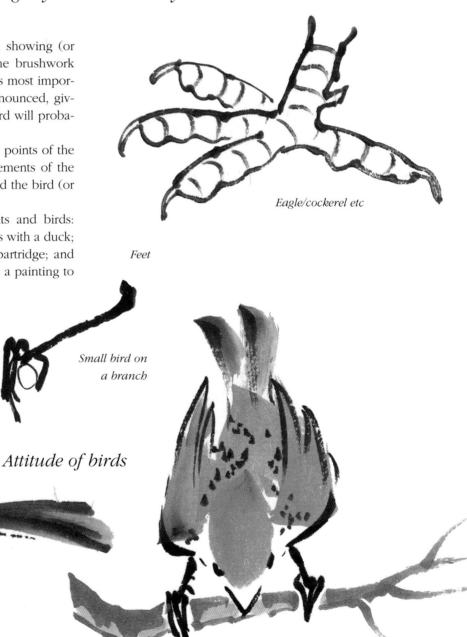

Eagle/cockerel etc

Feet

Small bird on a branch

Attitude of birds

Secure on the ground

Secure on a branch

Swallows with a willow

This is an example of how to handle a traditional subject.

1 Start with the head and wings in black ink, adding any extra, thin lines to complete the wings and tail feathers.

2 Add the beak and eye, plus a line for the breast. A small amount of red for the chest colour should be placed under the eye. Try to make the birds slightly different. It would be best to let the birds dry before completing the painting.

3 The willow is painted in the background with a mixture of dry and wet strokes, including dark and light shades as well. Colour is added in a subdued manner.

Large birds

Beginners should probably start with the eye, but this is a guideline rather than a rule. You could leave the pupil until the last stroke of the painting to ensure that the bird is looking at the correct point. Once you have placed the eye and beak, much of the character is set. The head and wings should follow, then the tail, breast, legs and feet.

Decide whether to paint the bird in a detailed style, showing the breast feathers and markings, as in the peregrine falcon (painted from a photograph), or in a more sketchy manner, like the fierce, but slightly daft-looking, eagle. Here, it is the 'wet-and-dry' strokes combined with 'light and dark' that are so effective. Notice how the various areas of paint and paper add interest and help to give the impression of many feathers. There are several bird centres where wild birds such as these can be studied. To really make a good painting, consider several visits to watch how the birds move and preen. These predatory birds, along with owls and others, are often shown on their own, or with something strong, such as pine trees. Smaller, prettier birds are usually painted combined with flowers.

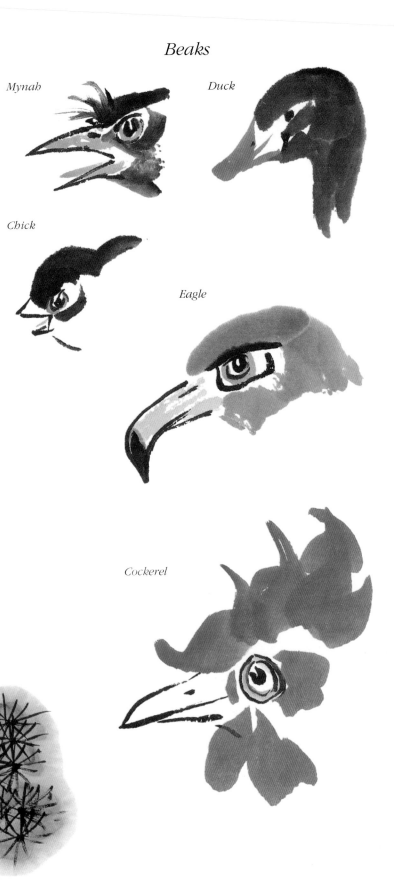

Beaks

Mynah

Duck

Chick

Eagle

Cockerel

Peregrine

Eagle.

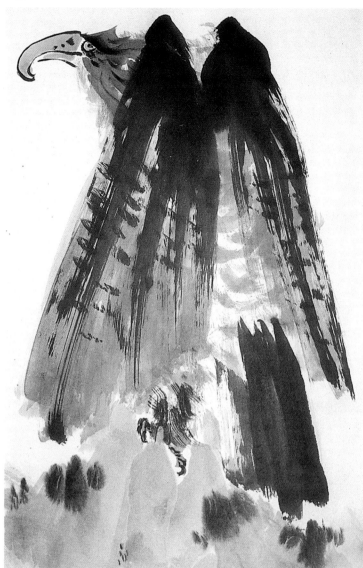

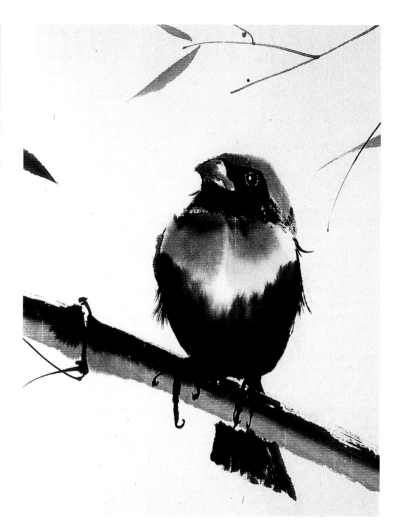

Small birds
by Kalpa MacLaclan.

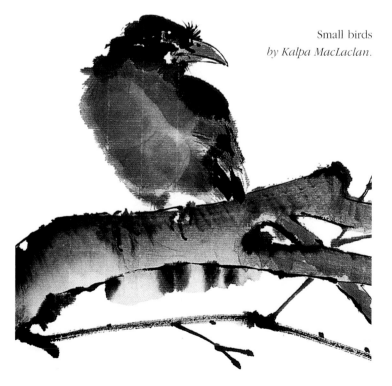

Small birds

There are two ways of painting small birds. The first is to paint the eye, beak, head and wings, followed by the rest of the bird. The second is to start with the breast, add the head and then the wings and tail. Try both ways and perhaps vary the order of painting to suit your mood. It is usual to paint the branch or perch after the bird, but, if it is completed first, remember to leave gaps in the correct places for the feet to overlap it. The tail or wings will need spaces as well, depending on the pose of the bird. There is no hard and fast rule, but in general try to paint what is in front, as in a flower painting. Remember that the distance from the beak to the tail is quite long, and therefore the tail can be painted with less detail and with a suggestion of being 'behind'. Consider the perch before you start to paint – it should be suitable for the bird. Sometimes small birds are shown on reeds or grasses, and these could suggest that the bird is 'balanced' rather than 'secure'.

Small birds on a branch

These are always popular subjects. If painted with their beaks open looking at others, it is easy to imagine the noise of their calls. The grouping is more important than the background. Make sure you do not have either equal-sized groups or equal gaps between them.

1 Start the group by painting the breast of each bird. Even though these are the first strokes, try to angle them differently to each other, so that you see some from the side view and some from the front or back.

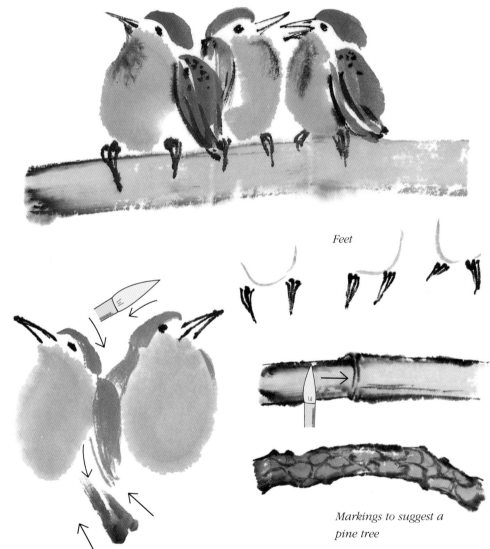

Feet

Closed beak

Open beak

2 Add the beak and eyes to each one, showing some with beaks open and others obviously silent.

Markings to suggest a pine tree

Wing

3 If they are appropriately angled, show the wings and the tail. Remember that the tail is a long way from the beak, and flick the stroke from the bottom of the tail upwards. Leave room for the feet.

4 Lastly, paint in the branch and add the feet and any markings. If the birds are sitting on a bamboo stem, paint the stem before the bird, and remember that the tails may be out of sight behind the bamboo.

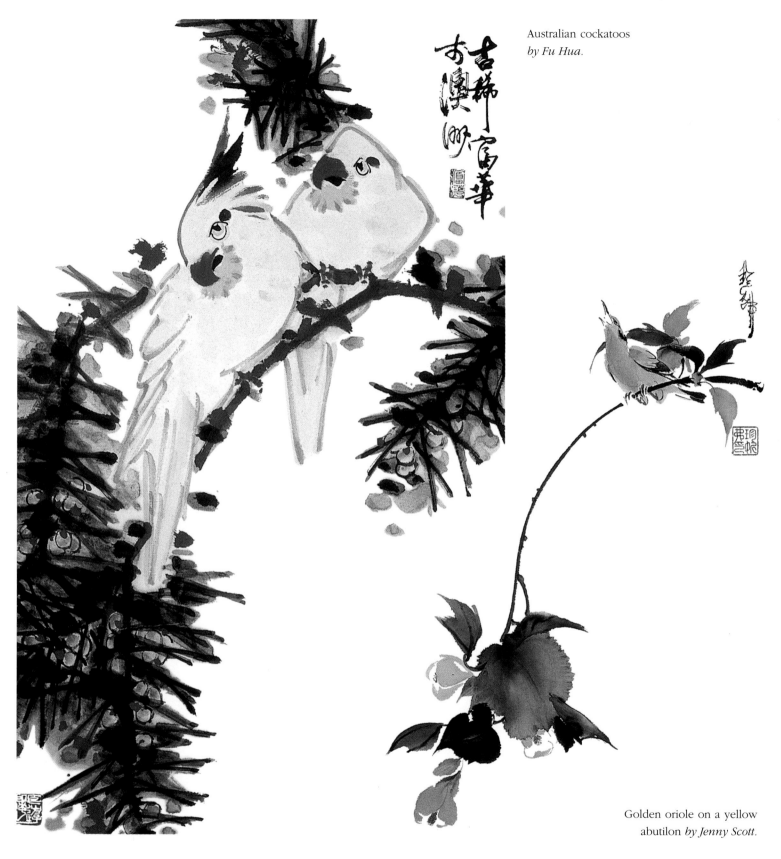

Australian cockatoos
by Fu Hua.

Golden oriole on a yellow
abutilon *by Jenny Scott.*

Fu Hua (a Chinese artist living in Britain and Australia), delights in painting birds of all sorts, often rather unusual, but they are always full of spirit and character. His

cockatoos in the Australian pine tree shown above provoke many comments from viewers – with everyone agreeing which is the male and which the female!

Jennifer Scott shows the golden oriole to fine advantage, singing on a yellow abutilon. The drama of this painting is formed by the wonderful, strong stroke of

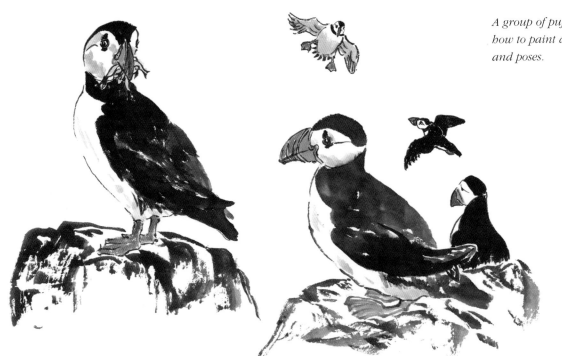

A group of puffins demonstrates how to paint differing angles and poses.

the stem linking the two elements of the composition. It takes a lot of practice and brush skill to achieve such a good stroke.

The inspiration for a subject comes from many sources. Puffins are such comical birds (they are also called sea clowns or sea parrots), and the combination of their black-and-white colouring and the bright colours makes an ideal, yet unusual, painting. This example shows several poses. Once the head is painted, the rest of the body is easy. When painting a bird that has black or dark plumage, beware of making it totally black. Leave some paper showing, or it will be lifeless. These birds are clumsy on land, but are able to stand upright. In flight they move with an enormous number of wing beats and have a distinctive outline. Do not be afraid to try different birds or settings. Just ensure that you leave something to the imagination.

The two birds by Dai Ying show a wonderful use of wet-and-dry brushwork and the technique of running ink. They also show that straight lines and perfection do not add excitement to a painting, but rather that lively lines make birds of great character. The water bird could be cautious or afraid of missing something. The range of ink tones, length of the strokes and the interplay of space and paint is also good here.

The small bird is on a large painting of wisteria, and the running ink contrasts with the dry strokes, suggesting an untidy bird, perhaps. It certainly seems tired, or bashful, and is quite dwarfed by the coils of a very healthy-looking plant.

By contrast, the fan painting of the budgerigars is quite different. The fan is made of two or more pieces of paper fixed together. This means that the surface has the effect of being sized, and therefore the ink and pigment do not soak in immediately, nor do they run. However, there is a danger of smudging it while wet. The birds are painted in detail, together with the

Bird by Dai Ying.

Water bird. Part of a painting by Dai Ying.

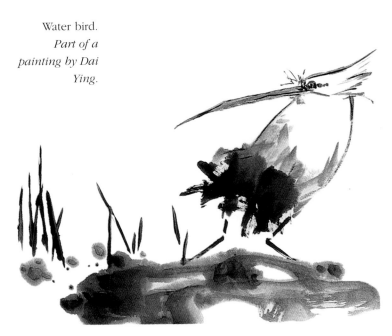

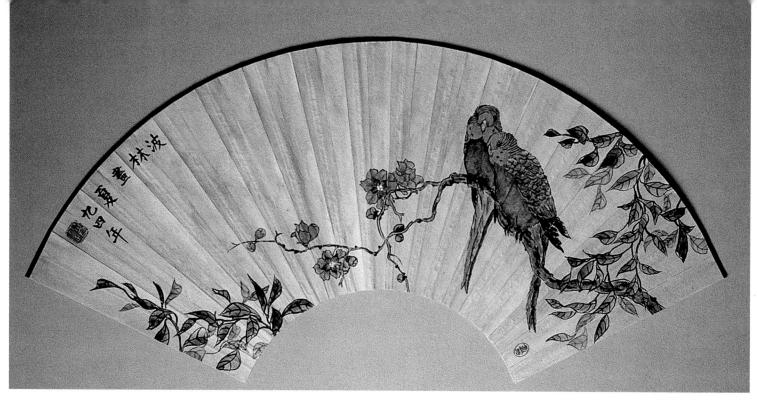

Budgerigars on a fan.

flowers in the background. Notice that the birds appear quite comfortable on the branch. The background has a wash over it in various pale colours.

Be aware of the overall composition when adding birds or insects to a painting. Try to avoid thinking in a 'Western balance' way, and maybe making it all too even. Above all, the attitude of the bird or insect should be lively. If a bird or insect has settled on a branch or leaf, then it should seem stable – unless the aim of the picture is to capture the moment just before flight, or catastrophe.

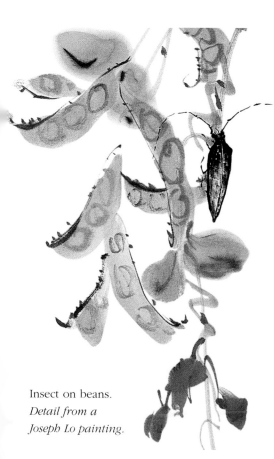

Insect on beans.
*Detail from a
Joseph Lo painting.*

Insects

Adding insects to pictures provides more information on the subject or the scene. They must be painted in a sympathetic, appropriate style and scale. The outline style of painting will increase the impression of fragility. Or use solid strokes for the body and wings to make a more dominant impression. Insects can be positioned on plant material, at ground level or in the air. The most popular are bees and butterflies.

Bees

Suggestive of summer, honey and hard work, bees are often shown bustling around flowers. They are seldom shown in great detail, but with the impression that the wings are moving very fast.

There are numerous different styles of depicting bees, so find one that suits your preferred way of painting. Make sure that the composition is not even. When positioning the bees (probably after the flowers have been painted), practise the strokes first on a separate piece of paper. Cut out the test paintings and place them on the final work to consider the composition. Once you are happy with the grouping or position, add it to your painting. Use this method for positioning any insects or birds, or even items in a landscape, such as small boats.

Butterflies

There are many legends about butterflies – often about the spirits of star-crossed lovers – and they should be painted to suggest their ethereal nature. It is easier to paint the wings first, followed by the body and the very fine legs and antennae. Do not paint the butterfly in too detailed a style, unless it is the main subject of your painting. They do not stay still long enough to see every mark. Photographs are useful as guides to the shape and position of the various elements, but make sure that you do not paint every marking. Keep the feet and antennae very light, and use a dry ink stroke. Some artists in the past used soot from burnt rice plants to make special ink for painting such details.

Qi Baishi (Ch'i Pai-Shih) painted his butterflies and insects the other way round – a rather sketchy flower with an immaculate butterfly – on very absorbent paper. This takes a lot of skill and control of both ink and brush. One of his paintings has a spider on its web in the bottom right-hand side of the scroll, with a bee at the top of the painting. The two are linked by some very cursive calligraphy down the right side, and one is left wondering how long the bee will retain its freedom. 'Happenings' such as this add interest.

Insects should be appropriate for the scene or the flowers. A dragonfly with a lotus is ideal; the dragonfly has a sizeable body, yet gossamer wings, making a contrast to the big leaves.

Insects of all kinds can show the passage of time – where many stages of flower or fruit growth are shown, they can be painted hovering above ripe fruit or seeds. They can also suggest a season, or at least reinforce the impression given by the flowers.

Other suitable insects are cicadas, wasps, ladybirds, ants, crickets and the praying mantis. Make sure that the insect is appropriate and that it enhances the painting in some way.

The colouring of the dragonfly is often kept pale to provide contrast between the large flower and the dainty insect.

Lotus and dragonfly by Joseph Lo.

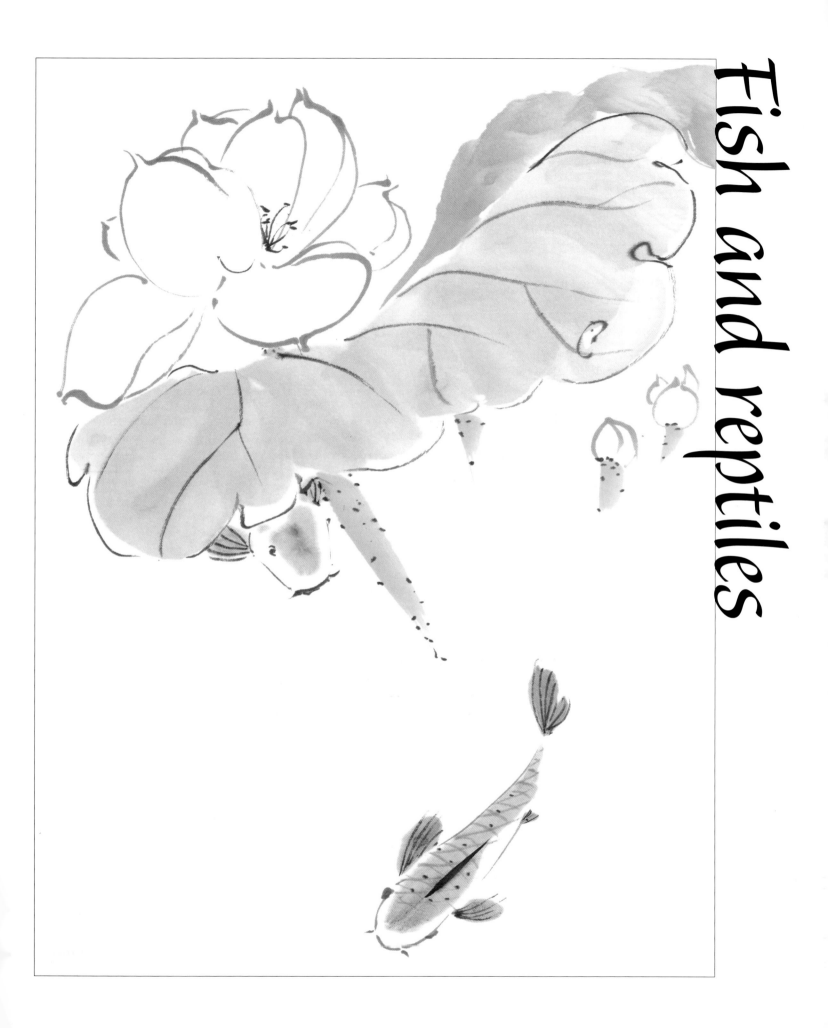

Fish and reptiles

Fish

The Chinese loved to study fish in ponds and lakes, watching the movement from above. Even when carp were kept in pools and bowls in courtyards, they were still viewed looking down on them, rather than through the side of aquariums, as in the West. Chinese paintings reflect this viewing angle.

Fish are ideal subjects for Chinese brush painting because they lend themselves to a fluid painting style, with the potential for showing the subject in just a few strokes. The artist can hint at a feeling or mood just by the composition. Sometimes paintings depict a single fish, others a shoal; a carp may be leaping or sedately swimming. The background or surroundings might be hinted at or shown in detailed profusion. The artist can choose to portray either tranquillity or drama.

Fish are associated with many legends and meanings, which concentrate mostly on longevity, harmony and wealth. A pair of fish can also add good wishes to a bride and groom, and many pieces of jewellery, especially jade, feature fish for this reason.

When painting fish with flowers, the fish can either be painted below overhanging branches or above a flower, such as a lotus. The latter is more difficult to get 'just right'. The water surface is not shown, as the position and attitude of both fish and flowers should speak for themselves. Fish are usually shown either coming up to the water surface (maybe even leaping above it) or emerging from the protection of plants or lily pads.

Try to position the fish in a pleasing group, remembering the 'large and small', 'dense and sparse' principles. Think of groups being 'host' and 'guest'. Ask yourself if the spaces between the fish are regular. If they are moving towards the same goal, you will have tranquillity; if you place one or two going 'against the

Fish, using a few ink strokes in both dry and wet ink.

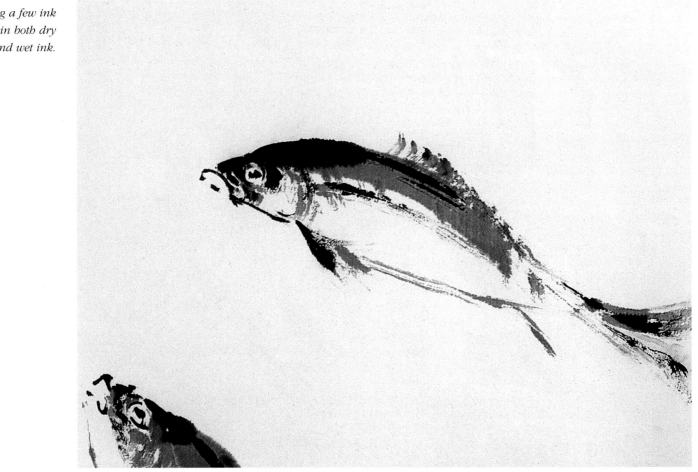

Elegant four-stroke fish

flow' then you will achieve more drama. Notice the difference between the fin positions. The character of the painting will change according to the angle of the fins: fanned out suggests a slow speed, and held tight against the body implies a faster pace. Try to leave spaces between the strokes, especially between the tail and the body – this will suggest fluid movement. Try to imagine the fins and tail by thinking of their structure. Hold your hand palm upwards. Open and close your fingers – this is how fish fins work. Remember this when you paint them.

Freshwater fish live in ponds, slow, sluggish rivers or in brisk streams. This difference in habitat tends to dictate whether the colouring is bright or muted. They can be painted in ink, with colour included in the ancillary subject or background, or in colour themselves. You can paint a very recognisable species or show many small fish which may be sprats or minnows. The main achievement is to show the fish in their environment, and to hint at their movement and speed. Fish paintings are usually happy and joyful, full of darting movement.

Fins indicate 'fast'

For fins

Fins indicate 'slow'

Hide tip

Small fish, with minimal strokes and background.

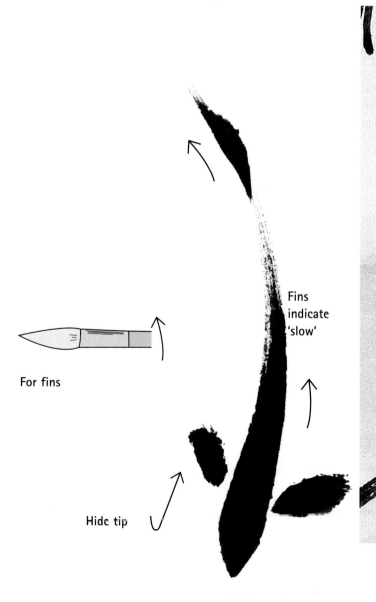

Fish with lotus

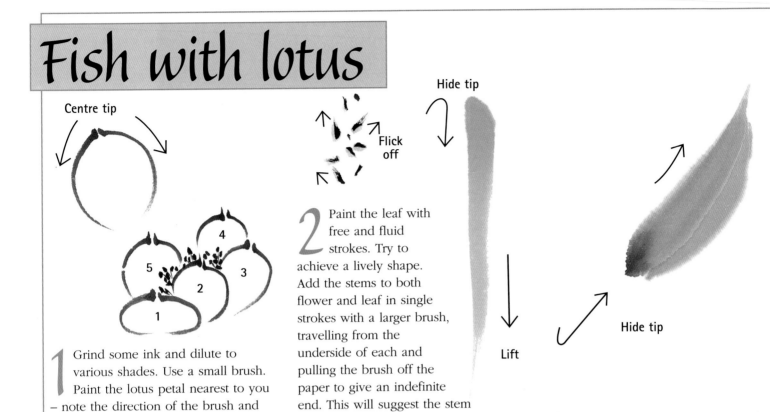

Centre tip

Hide tip

Flick off

Lift

Hide tip

1 Grind some ink and dilute to various shades. Use a small brush. Paint the lotus petal nearest to you – note the direction of the brush and movement. Paint the petals in two strokes, working to the back of the flower. Do not join one petal to the other – make sure that you leave a small gap. Add the pollen dots.

2 Paint the leaf with free and fluid strokes. Try to achieve a lively shape. Add the stems to both flower and leaf in single strokes with a larger brush, travelling from the underside of each and pulling the brush off the paper to give an indefinite end. This will suggest the stem disappearing into the water. Once the paint has had a chance to dry a little, add some flick strokes (from stem out into the water) to suggest the rough, prickly surface of the lotus stems.

3 Load a larger brush with grey ink and tip with black. Paint two strokes side by side for the back of the fish. Do this from the head to the tail; some ink on the tip will help.

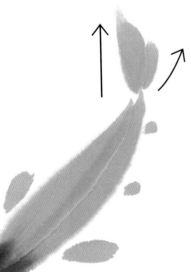

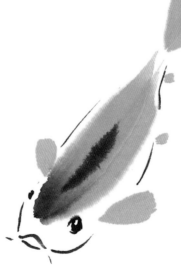

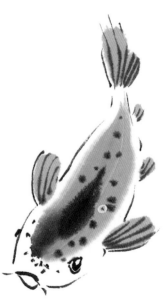

4 Add the fins and tail; ensure that the strokes are different sizes, one for each fin and two for the tail. Leave a gap between the body and the fins/tail. If the body is at an angle, the swimming fins may be different.

5 Using black ink and a finer brush, add the dorsal fin as a single stroke, and include the eye(s), mouth and a few strokes for the body. The undersides of fish are often silvery and not well defined.

6 Add dots to indicate scales here and there (not evenly), and paint some 'veins' on the fins to show how they open and close. Make sure that these are like a fan rather than a row of fencing. A 'cheeky' fish is good.

This painting can have colour added if you wish. The More advanced techniques chapter (page 107) shows how this may be painted on a different paper and combined with washes to achieve a more atmospheric painting. The inkwork necessary to achieve this is very important and worth the patience required.

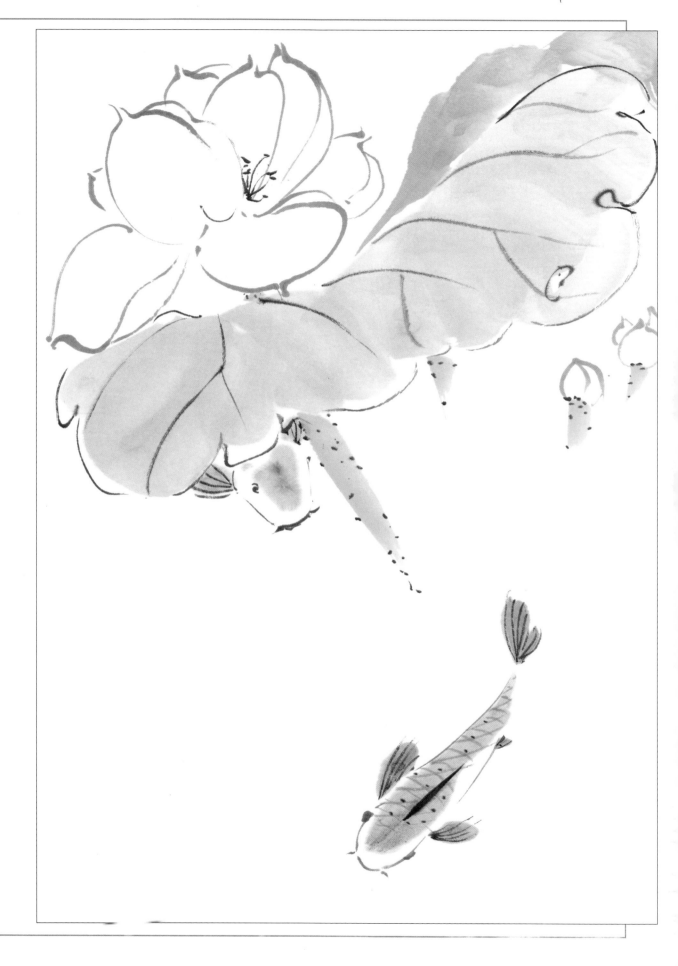

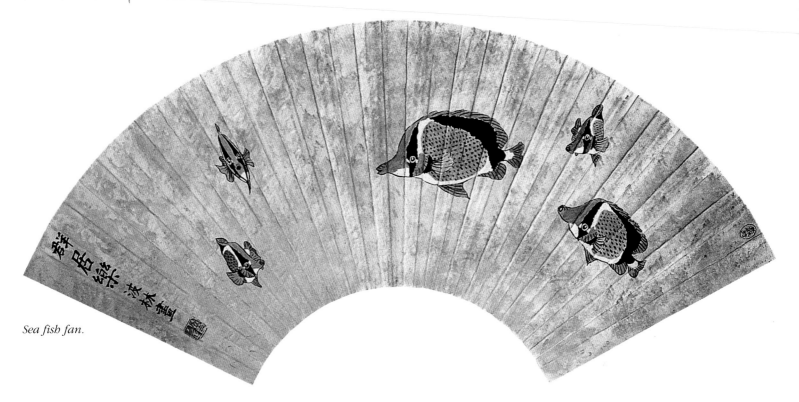

Sea fish fan.

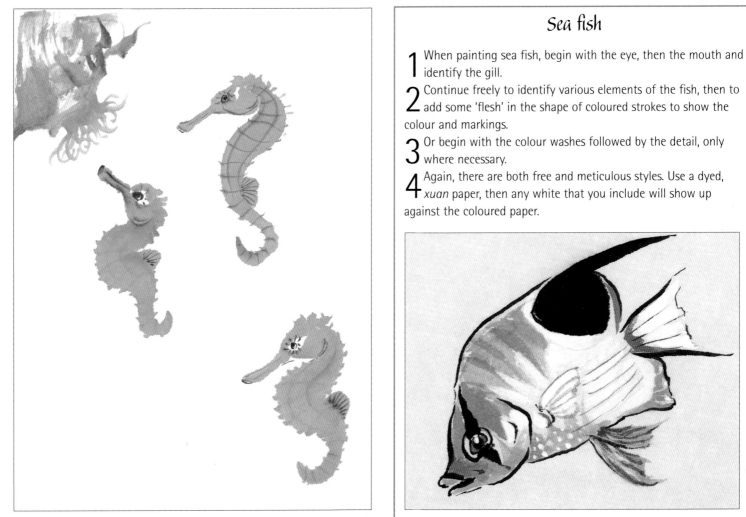

Seahorses and anemones – have fun!

Sea fish

1 When painting sea fish, begin with the eye, then the mouth and identify the gill.

2 Continue freely to identify various elements of the fish, then to add some 'flesh' in the shape of coloured strokes to show the colour and markings.

3 Or begin with the colour washes followed by the detail, only where necessary.

4 Again, there are both free and meticulous styles. Use a dyed, *xuan* paper, then any white that you include will show up against the coloured paper.

There are many different styles of painting fish, from the exotic to a very free style, and a selection are shown here.

Sea fish

Some sea fish live in the deep, while others are the bright, colourful varieties of the coral reef. It is the latter that tend to be painted. Sea fish do not share the sinuous nature of their fresh-water cousins, and against their bright colours the background can seem quite experimental and dark. Try using a natural sponge to introduce some texture – but, like all things in Chinese painting, do not overdo it. The fan painting illustrated incorpo-rates a sponged background.

Notice that the fish are sometimes painted facing the viewer and sometimes from the side. Because the fan is constructed with pockets (to take fan sticks), the effect is like painting on metic-ulous or sized paper.

If you find it difficult to change the attitude of a fish, cut it out of the paper and twist it to see different poses. When paint-ing with children, or if you want to enjoy a different subject, try painting a seahorse, which is usually shown with soft colours, although it is well camouflaged in reality.

Goldfish painted in the Xieyi *style.*

Elegant tropical fish with floating fins.

Another area to explore is tropical freshwater fish. Many originate in the muddy waters of Asia anyway, and as subjects can be tackled in the same way as the sea varieties, as they are often brightly coloured. Some are not so agile or flexible as the carp, and the background can be suggested perhaps by painting some flowing weed to show river currents.

Although they are not so popular with Western artists, fish for eating are sometimes shown with vegetables or fruit, as are crabs or other aquatic creatures. Both *Gongbi* and *Xieyi* painting are used for these subjects.

Zheng Naiguang has produced paintings of this genre, including various crabs, mussels, scallops and limpets, often shown with Chinese leaves or other leaf vegetables. They can be set in baskets or antique bronze containers. Some may find this a little gruesome, but in the past there have been many Western paintings of dead game birds and fish.

This Xieyi *example incorporates a 'still-life' scenario within the painting. These paintings are often used to portray good wishes for prosperity and wealth, and are popular at times of New Year or harvest. Joseph Lo.*

Reptiles

The dragon, the fifth animal of the Chinese zodiac, is regarded as the chief of the 369 scaly types of fish, snakes and reptiles. The Chinese dragon is not the winged, fire-breathing variety of the West, but a more sinuous version, often bad-tempered. There are said to be three types: one living in the sky (the true dragon), another in the ocean and the third skulking in marshes and mountains. The ocean dragon is often portrayed in cartoons; children's stories depict four dragon kings, (red, yellow, blue and green) living in a different ocean (north, south, east and west).

Most dragons in paintings are the sky variety; they are shown playing in the clouds, chasing each other, often causing rain and storms, which the local populace might have been praying for, and trying to catch the 'pearl of wisdom'. Dragons on embroideries and porcelain items are frequently detailed and highly coloured. Paintings can be more free, and the dragons themselves may appear friendlier.

There are many descriptions of Oriental dragons, which are not winged; they incorporate the 'nine resemblances', which vary depending on the source material. Traditionally, they have rabbit eyes, an ox nose, a camel head, deer horns, tiger teeth (maw is sometimes confused with paw), a snake body, fish scales, a clam belly and eagle claws. At one time only the emperor could have a dragon with five claws shown. Everyone else had to use dragons with a mere three or four claws, and this was a serious matter.

As they are mythical creatures, no one can dispute the appearance of individual dragons. Of course, you could also use hints from other paintings in this book. White paint or alum could be used for the scales before the body colour is added. There will also be a different, but rather softer, effect if you add these afterwards instead. Gold or silver water-based paint may be used to suggest the scales on a more opulent painting. Do not make the lines too neat.

Dragon

1 Use a small brush loosely to ink in the eyes, nose and mouth. Draw the body and tail, first using an ink line for the outer edge and then filling in colour with a larger brush and fluid strokes.

2 The legs and claws are now added, together with other details. Any spots to suggest scales should be added while the body colour is still damp, so that they blend.

3 For a more detailed technique, roughly 'outline' the scales rather than using the dots. The pearl of wisdom has many different forms, but it is usually surrounded by flames.

Snake

The snake, another of the zodiac animals, is not often portrayed in Chinese brush painting. It does, however, provide an opportunity to use particular techniques to decorate the body.

First, decide where the creature will twist across your painting. Use your fingernail slightly to indent the paper to provide a guide. Load a large brush with the body colour and follow the indented line with a single stroke, working from head to tail. Where the snake wraps around branches, stop and start again on the other side.

While the paint is still damp, add ink dots to give markings along the body. Do not be too neat about this – aim for variety. Alternatively, load a medium brush with white or pale-yellow paint (you need the white content for opaqueness) and paint a row of varying dots along the body line. Wash out the brush well and load it with grey ink or a light colour. Use a flowing stroke to paint over the dots all along the body of the snake (see Fig a). The dots will show through the ink/colour. Another way of achieving the same effect is to use a mixture of alum powder and water instead of white paint, which will leave a clear dot. To complete the painting, add branches and foliage.

A contour method is also effective, where the two edges of the snake are identified with intermittent lines (see Fig b). Markings are added, followed by colour washes if required.

The coils of the snake – as long as the reptile looks right, there is no need to show it all clearly.

Fig a

Opaque spots painted before the colour is added.

Fig b

The markings are added after the colour.

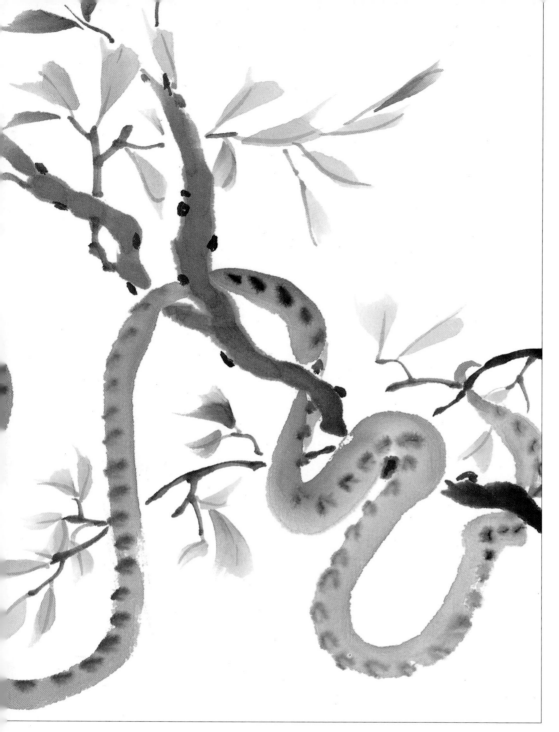

The snake is the sixth animal of the Chinese zodiac. Here it is shown curled sinuously amongst the leaves.

Frog on a rock.

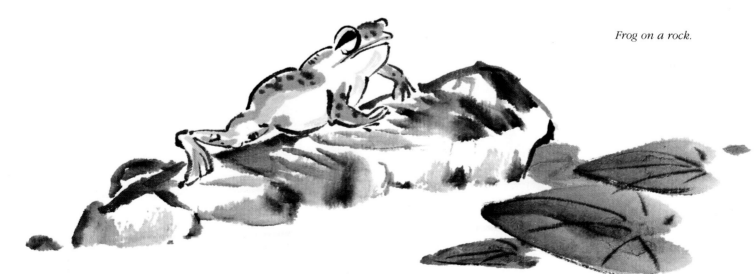

Other reptiles

Other reptiles, such as frogs, toads and lizards, can also be painted to good advantage. Use the minimum number of strokes to impart the maximum message. Again, both solid strokes and outlines can be used. There should be variation in markings and colour. Try to suggest the type of movement for each different reptile – slow, sleepy lizards, frogs about to leap, or maybe a warty toad skulking under a leaf. Compositions may be of one creature or may incorporate several. You may wish to combine different creatures, but avoid painting a 'zoo'. Usually two varieties are sufficient.

When painting reptiles, it is often preferable to perform the colour strokes first, capturing the posture and limb positions. You can later add only the necessary details. If you do them the other way round, you may be tempted to 'draw' too much.

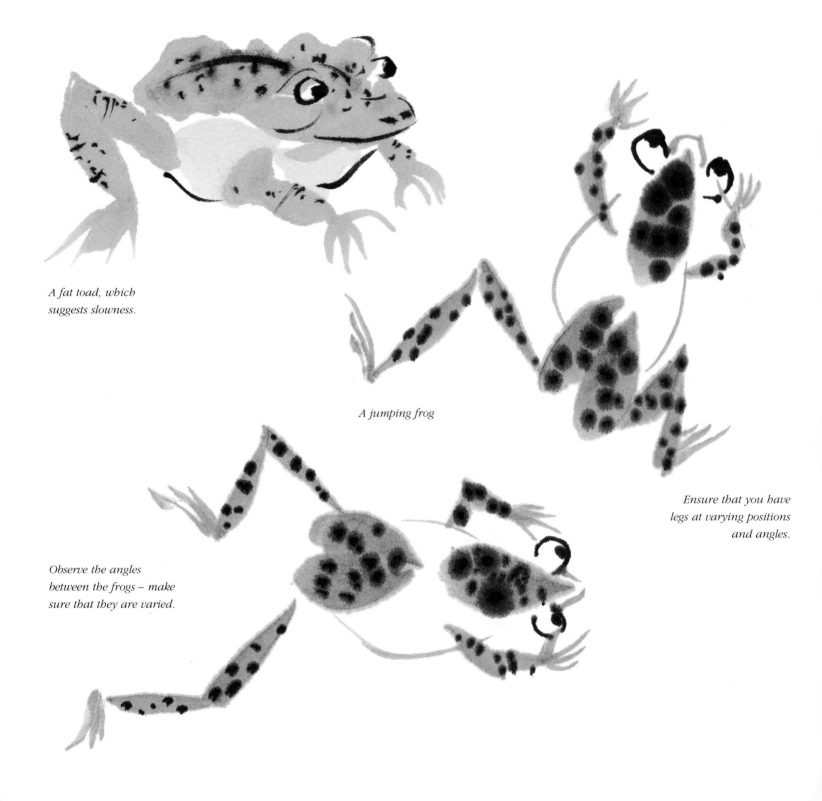

A fat toad, which suggests slowness.

A jumping frog

Ensure that you have legs at varying positions and angles.

Observe the angles between the frogs – make sure that they are varied.

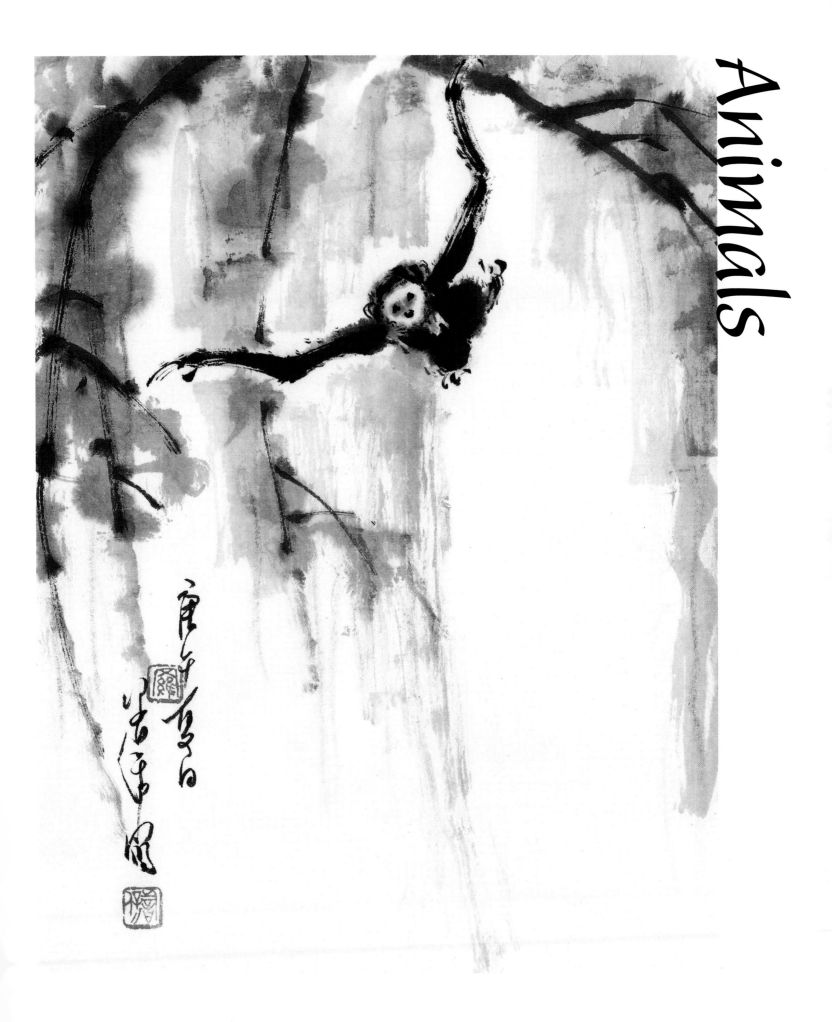

Animals

Animals

There are many ways in which animals can be portrayed in this art form. They can be painted one hair at a time on highly, or semi-sized, paper, or with just a few strokes on very absorbent xuan paper. The style and technique will depend on your preference, mood, and, in the case of meticulous work, patience. In the majority of cases it is the free-style versions that have most appeal. They need to capture the character of the animal – its youth or maturity, the softness or hardness of its skin or coat, and maybe its strength or ferocity.

There are twelve zodiac signs in the Chinese horoscope; the dragon and snake have already been mentioned, and the others are the rat, ox, tiger, rabbit, horse, goat, monkey, dog and pig. The rooster is the only bird. Several legends exist about both the selection of these creatures and their order in the zodiac. These animals are often painted as part of the celebration at the start of each Chinese New Year or as a present for someone of that sign.

The tiger, for instance, lends itself to large, stunning paintings.

Many animals have symbolic meanings, such as longevity, fidelity or strength, in addition to being part of Chinese culture. Paintings of domestic animals, such as cats, are popular – some are very pretty, but do not 'say' anything about the spirit of that creature. The stance and expression of the animal must convey the artist's message to the viewer.

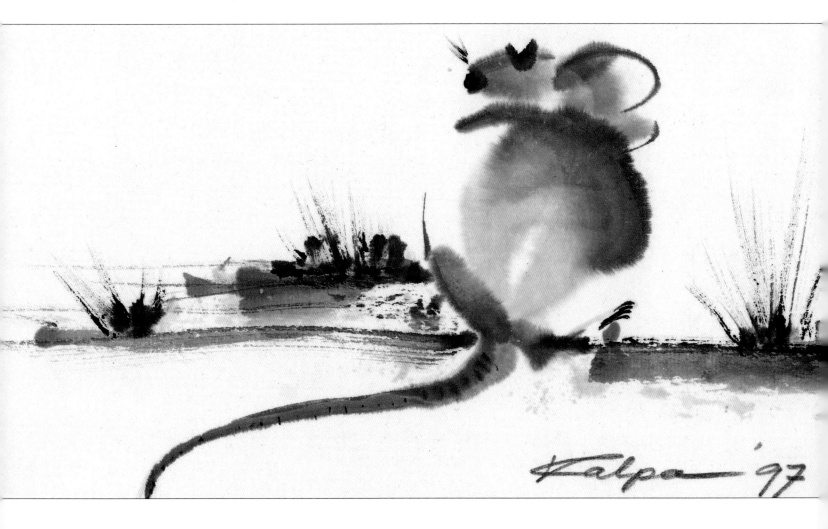

The monkey, by Joseph Lo, shows a lot of movement and an ability to jump through the trees. The arms are longer than most, and the paws are held out to grip the branches on landing. There is an impression of agility and gracefulness in this painting. The fur is shown by small strokes – this can be done with a split brush. The background is only included to show where the animal is going, and its starting point.

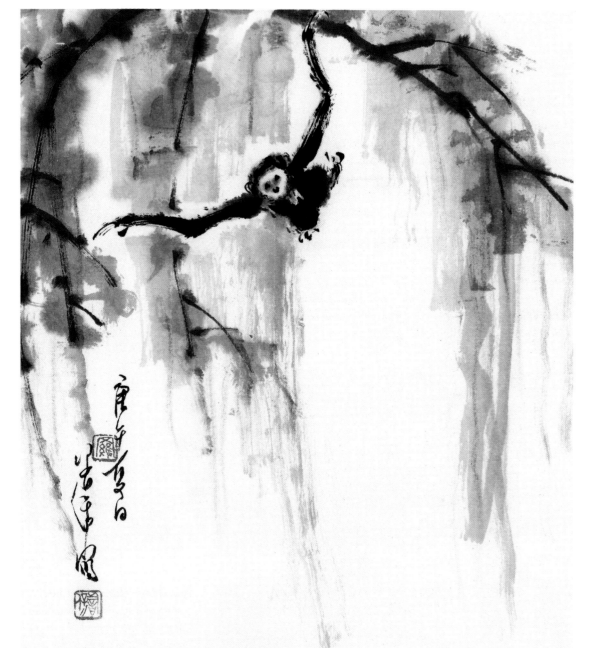

Mouse *by Kalpa MacLachan*

Tips for painting animals

1 Decide on the character of the animal, how it will be viewed, and whether it is to be in shades of ink or in colour, then select the appropriate paper. In general, animals are painted on absorbent paper to give a softer appearance.

2 As with birds and aquatic creatures, the eyes of animals are often painted first, followed by the nose and mouth, and this usually makes the character of the beast apparent. Proficient artists can, of course, start where they like. It is often an advantage to paint the animals first and to add the background later. It is not necessary to include a lot of detail, but just enough to suggest habitat or situation. Of course, it depends on the scene portrayed and the style used. Lingnan painters (a particular school of painters originating in southern China) often include a simple wash background, and the viewer must imagine the detail. Others may show no background at all.

3 Think clearly about the movement of the animal and therefore how the joints work. A cheetah represents speed, a panda is lumbering, a dog can be boisterous and a monkey able to climb. The feet and paws should hold the animal stable and a prehensile tail is vital for climbing. These features may not be shown in detail, but the artist must understand them in order to make a 'caricature' of the creature.

This golden monkey *is more of a 'portrait', in which you almost hear its cry, as well as feel its soft, yellow fur. The secret is only to paint enough strokes to show the coat without overdoing the amount of work. It is very easy to overload the painting and to make it look muddled. If you feel that the fur is not 'solid' enough for the animal once painted, add a light wash of the fur colour over the top, or on the back of, the body to tie the strokes together. Although the face is shown in detail, the limbs are suggested simply by the change in fur colour. Notice how the left arm is painted in front of the knee, which is in front of the other arm. Always paint what is nearest to you, and then work backwards. The branches and leaves are added later.*

This rather elderly and bored cat *is portrayed in loose strokes, with additional ink applied afterwards. The varying colours are loaded initially. It shows a convention which may seem rather unusual to Western viewers. The Chinese often paint the eyes of a cat in two different colours: light green and yellow. After all, the eyes are not both in the same flat plane on the cat's face and therefore reflect the light slightly differently.*

This squirrel, *by Joseph Lo, demonstrates the use of small strokes and a split brush in differing directions to ensure that the viewer sees the limbs and to give a fur effect. After the inkwork (or maybe before, if you prefer), a lightly coloured wash is painted over the body. This ties the strokes together into a better shape. In this painting you may wonder if the creature is just admiring the wisteria or whether it see something we cannot. The branch is only just hinted at, but the posture ensures that the squirrel is secure on it.*

This very elegant cat, *by Kalpa MacLachlan, from The Netherlands, shows how a few details and a lot of space can portray the character of a very superior animal. Once again, the colours and shades of the ink are very important. The small mouse, also by Kalpa, illustrates that the shapes of the strokes are as essential for recognition as the tones of ink.*

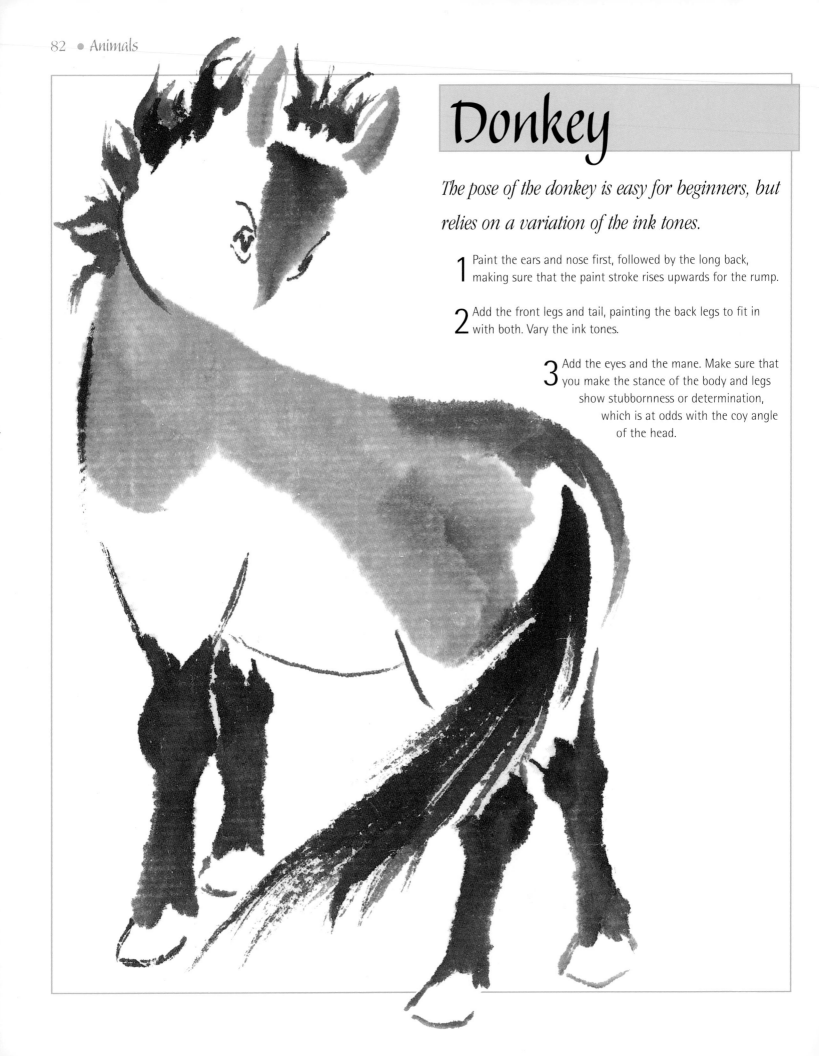

Donkey

The pose of the donkey is easy for beginners, but relies on a variation of the ink tones.

1 Paint the ears and nose first, followed by the long back, making sure that the paint stroke rises upwards for the rump.

2 Add the front legs and tail, painting the back legs to fit in with both. Vary the ink tones.

3 Add the eyes and the mane. Make sure that you make the stance of the body and legs show stubbornness or determination, which is at odds with the coy angle of the head.

This small kitten, by Kim Duffell, relies on the use of bark xuan paper to give absorbency and texture to the strokes – there is a contrast of wet and dry strokes.

This Pekinese dog also depends on varying shades of ink and linework. Here, the coat is important. During the second century BC, merchants exchanged dogs for silk – mainly the small dogs bred in Malta. The palace eunuchs embarked on a breeding programme to achieve the 'ideal dog'. At the same time, the first lions came from India and the Maltese dogs were bred with the indigenous pug to produce 'lion dogs', also known as Pekinese, after the capital, Peking (now Beijing). A smaller version was bred as a 'sleeve dog', to be carried in the sleeves of concubines and mandarins, and the dowager empress kept at least a hundred Pekinese dogs as pets.

In any animal painting, try to include the essential characteristics of the creature. In order to develop your work, gradually eliminate strokes or markings with each version that you paint, until you have only used the minimum of brush marks on the paper.

This giraffe *shows how distinctive animals can be included, even from other continents. The feet are omitted to give the idea that it is standing in long grass. The angle of the head continues the line of the body and neck up to the foliage.*

Figures

As with many aspects of Chinese brush painting, figures can be painted as the main subject of the proposed painting or may feature as a small part of a landscape. Figure painting is thought to be the oldest element in traditional Chinese painting, as everyday scenes were portrayed on the walls of tombs.

The Chinese (Daoist) concept is that mankind is unimportant in comparison with nature. Therefore, when figures are shown in a scene, they are disproportional to the mountains and other landscape elements. In the same way, servants were shown much smaller than their masters, giving rise to the misconception that children were carrying books and equipment for the scholars who were immured in the mountains while 'communing with nature' and painting or writing poetry.

Chinese paintings are obviously a useful source for studying figures. Journals and calendars, and books about life and scenery in China, are invaluable. Chinese legends and stories, such as 'The Outlaws of the Marsh' (also known as 'The Water Margin'), 'Monkey' and other classics, even children's books, incorporate a wealth of information and inspiration. Pictures brought to the West by travellers during the earlier part of the 20th century are another good source for clothes or poses. While not necessarily being in popular taste, they are relatively cheap.

When painting figures as the main part of the painting, decide whether the painting is to be a portrait or whether the attitude or action of the figure is of prime importance. Portraits are a little unusual in China, and there was a time when only the emperor was considered 'strong' enough (as 'the son of heaven') to resist the evils of having a likeness made – even then, it was only for record purposes. Any painter who carried out this style and purpose of painting was considered very lowly.

Often the qualities of a figure are exaggerated, showing proudness, strength, resistance or being downtrodden. Many paintings, especially those from the era of the Cultural Revolution, show heroic stances.

A monk meditating on a prayer mat in his quilted robes.

Large figures

There are two main techniques for larger figures. The first is to paint with large, free strokes in colour or light ink, followed by a limited amount of detail. The scholar and his apprentice (loosely based on a pottery ornament) shown under the pine tree had their flesh and clothes painted in a free way, starting with the faces, hair and hands, followed by the clothes. Do not add too much detail and ensure that there is some paper showing rather than just bland areas of colour. The pine tree in this example was added last of all. If the subject is gazing at something, such as the look exchanged between these two, leave the pupils of the eye until the end of the painting. You can then ensure that the gaze is correct.

'Ink'. *Scholar and disciple under a pine.*

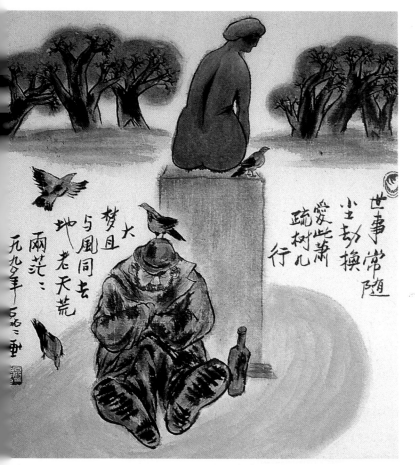

'A Rest in the park' *by Qu Lei Lei.*

'Drunken princess', *a painting of a well-known opera figure by Kim Duffell.*

Technique 1 – free strokes

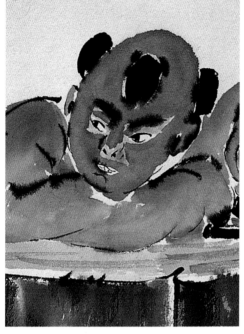

1 To paint the face in this way, start with a 'T' shape for the nose and brows using a flesh colour.

3 The hands can be painted from the fingertips down – look at your own hands for the positions. Be careful not to 'draw', and only add clarifying ink lines where necessary.

4 Use brush loading for the clothes to suggest some folds rather than adding additional lines (dip the tip of the brush into a darker colour and use the angle and position of a sideways brush to give you the modelling). The two pictures here show how this technique can be successfully applied.

The painting apprentice – detail from 'Ink'.

Scholar (detail from 'Ink') – using free strokes for the flesh and clothes, with details added as necessary (stages).

2 Add the eyelids, cheeks, upper lip, chin and neck. Depending on the hairstyle, you may need to include the forehead. Start to include the clothing, but before the face is completely dry add some features, so that the strokes bond with the skin colour and do not stand out too strongly. The details of the skin should be in a lighter ink than the clothing lines to show the difference in surface and structure. The hair should have some 'flying white' to suggest the strands, even in a free-style painting. Paint a light ink wash over the hair to amalgamate the strokes, while still leaving the texture.

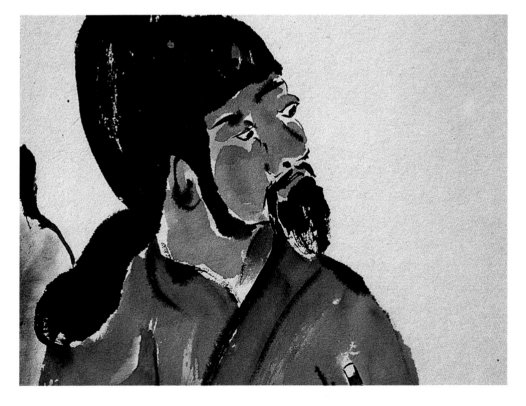

Technique 2 – detail

An alternative method of painting is to paint the details first (being very careful not to 'draw' in the Western sense) for the whole figure, followed by the addition of colour.

'Washing in the river' – note how the fabric is painted to make it look delicate.

1 First paint in the pupils (using two 'U'-shaped strokes) and then add the eyebrows.

2 Use light ink to paint in the nose, chin, mouth, as well as the other facial features.

3 Define the hair line with a split brush, and use the hair to show the shape of the face.

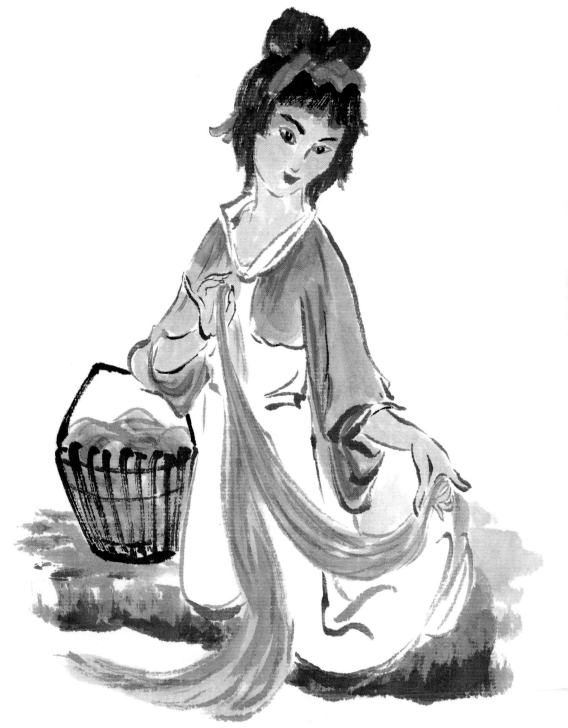

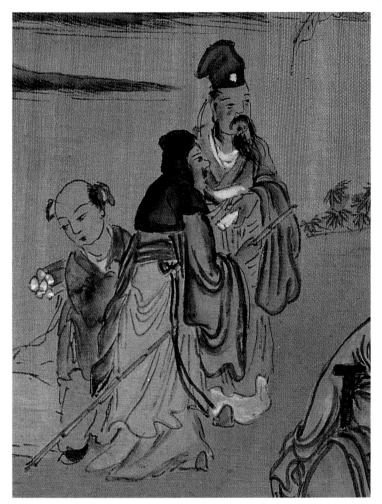

Fig 1 *Small figures – detail from a painting, artist unknown.*

The example of the rather smart lady washing her delicate scarf in the river shows how this can be done. Again, you should leave some space for the paper to show through rather than 'colouring in' the painting.

In both of these examples the linework should be interesting and not boring. Make sure that it is not like a line from a pen, and leave some gaps to 'allow the *qi* to circulate'.

Many examples of figure painting are performed in the meticulous style, especially for decorative purposes. This style takes takes a lot of skill, time and patience and is included in the More advanced techniques chapter (page 107).

Small figures

Less detail is required for smaller figures. The attitude and posture are still very important, as are the linework and colour. All of the same points apply, however small the figure – leave gaps in the lines, do not colour in the shape and remember to leave a little to the imagination.

If you paint an urban scene, it may include several figures. If it is the pathway to a temple, there may be pilgrims on donkeys or supplies being ferried from a city somewhere. However, in a rural scene, in order to reinforce the loneliness, the majesty of the mountains and the total insignificance of man, do not include too many figures. The attitude of the figures is the important element, and can help take the viewer through the painting. Figures may be walking, working or just looking around them.

The small groups of figures are from an old painting (artist unknown). It is not of high quality, and is painted on fabric, but it shows two interesting groups of figures. In the first, two gentlemen are dressed for travelling, while their servant carries some scrolls (Fig 1). The second group (Fig 2) illustrates one gentleman playing his flute, while the others listen – one does not seem too impressed. The other is leaning on his musical instrument (a *qin*). The book on the table suggests that these three scholars have been reading and discussing poetry, as well as playing instruments.

Some scenes involving figures express peace and tranquillity, others the bustle of everyday life. Many tell a story, with the figures moving from one area of the page to another. A rich source of small figures in landscapes are the 'record paintings' of an emperor's journey – these often spread across 70 or more hand scrolls. They involved a handful of painters.

Fig 2 *Small figures – detail from a painting, artist unknown.*

Landscape

Landscape

Most people think of soaring mountains and tall waterfalls seen through the mist when Chinese landscapes are mentioned. This is not a misconception, as the written characters for landscape are 'mountain' plus 'water'. The geography and topography of China have inspired artists, calligraphers and poets for centuries. It is the grandeur of the natural scenery which captured their imagination. Many Chinese court officials retired from public life to remote rural positions, spending their time painting, writing poems or indulging in philosophical discussions with like-minded peers. Their world was rather fanciful, and certainly left out any unpleasant features.

In the time of Confucius, it was stated that there were five pure colours – red, yellow, blue-green, black and white. Confucius himself only wore robes of black, white or yellow. From this strict dictate, later scholar-artists assumed that very little colour should be used in paintings. Colour later played a minor role because of the manual labour involved in preparing the pigments and the smaller number of servants available to carry out the work. From this time the 'five colours of ink' became important. Even mineral and vegetable colours enjoyed their fashions, the former in the Tang Dynasty and the latter in the Ming Dynasty. All this led to the appearance of 'ink and light colour' in traditional landscapes. These marvellously evocative scenes only show what the artist wanted to portray.

The Chinese knew about perspective from about the 8th century (knowledge that was not widespread in the West until the

Beautiful traditional landscape by Ya Min.

15th century) and then completely ignored it; artists were not interested in realism, but only in creating a particular impression. There were various traditional points of view for a scene, from low level (Fig 1), where trees and other features would form a large part of the picture, to high level (Fig 2), where the trees were at the foot of towering mountains. It is the latter that most viewers are familiar with in Chinese landscape paintings – almost as if you were looking from one mountain top to another.

Composition

Along with these viewing levels, there were many composition patterns. These are divided into 'great', or 'big' compositions, and 'little', or 'small', compositions. The first is a description of the overall appearance, the division of the paper and where the marks are made, The second category refers to the detail, the arrangement of secondary elements. I am indebted to Qu Lei Lei for making all of this clear to me, and for the ideas used in the sketches. For ease of illustration, the brush sketches are shown in the same size and proportion – adapt this to your work.

The following composition patterns are illustrated: interlocking, where elements overlap each other (Fig 3); diagonal, the pathway shown around the mountain (Fig 4); separated,showing each side of the river (Fig 5); concentrated, focusing on the bridge and house (Fig 6); open flat, with low ground near water (Fig 7); and opposite, as in the gorge (Fig 8). There are also

Fig 1 *Low level*

Fig 2 *High level*

Fig 4 *Diagonal*

Fig 3 *Interlocking*

Fig 5 *Separated*

Fig 6 *Concentrated*

Fig 7 *Open flat*

Fig 8 *Opposite*

Fig 9 *Linking*

Fig 10 *Layered*

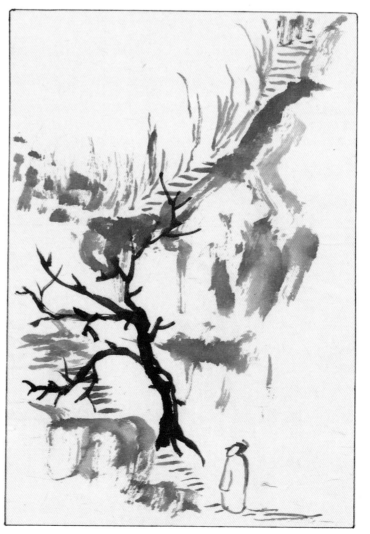

upright, broken, unbalanced, geometric and conversation. (The latter is where elements have a relationship.)

The 'little' compositions include linking (Fig 9) and layered (Fig 10). Others are called evenly arranged, open and closed, separated, snaking and 'living eye'. Most of these are self-explanatory, except for the last, where the grouping draws the focus in towards one corner (such as the source of a waterfall, for example). It is fun looking at paintings and deciding which category they fit into, and it also helps viewers to study paintings with a more critical eye.

Other elements must be considered within the composition of a traditional landscape. The main three are rocks, water and trees. Rocks are regarded as the skeleton of the land, full of force and strength. These should be painted with vigour, taking care to paint the 'three faces': look at the sketch of the blocks. The water seeps and flows through the gaps in the rock formations,

always fluid and flexible, like the flesh or muscle of the land. Trees are seen as the clothes with which the land is covered. They take on the character of the setting. In a wild and rocky landscape there may be rugged, even windswept, pine trees. In a wide, fertile valley, trees in blossom add colour and softness to the scene. Decide on the effect that you want.

Rocks

Rocks show the geology of a scene. If you were to travel on a cruise down the Yangtze river, the shapes of the rocks would be instantly recognisable, as they are the same shapes as many brush strokes. Many of the strokes have names such as 'lotus vein', 'unravelled hemp' or 'brushwood'. Do not use too many variants or the scene will not have cohesion. Old painting manuals talk of the rocks being 'alive'. One way of painting a range of mountains and/or rocks is to think of 'host and guest'. There should be a dominant peak and one or more supporting elements. This helps to give the painting a pleasing 'balance'. The scale of the painting will dictate how much detail you use to illustrate the character of the rocks.

A landscape is often painted in three tones or shades of ink. Notice the differences between the examples – practise the strokes and inkwork, starting with the pale grey. Visualise, or to start with, sketch, the 'boxes' and paint enough lines to show both the outline of the rock and the basic shaping. Do not make the lines continuous, but allow the spirit of the rock to be free. Once the main areas have been painted, add darker ink where it is necessary to describe features in more detail, trying to reinforce the concept of shape, but without going over the previous lines exactly. Ask yourself if you are adding information. If the answer is 'no', then stop adding lines.

Finally, any prominent points or foliage should be added using very dark ink. This helps to give depth to the painting – dark ink should not be used in the distance, but only in the foreground. As the rocks recede into the background, you should decrease the variation in the ink until you are using only pale shade in the distance.

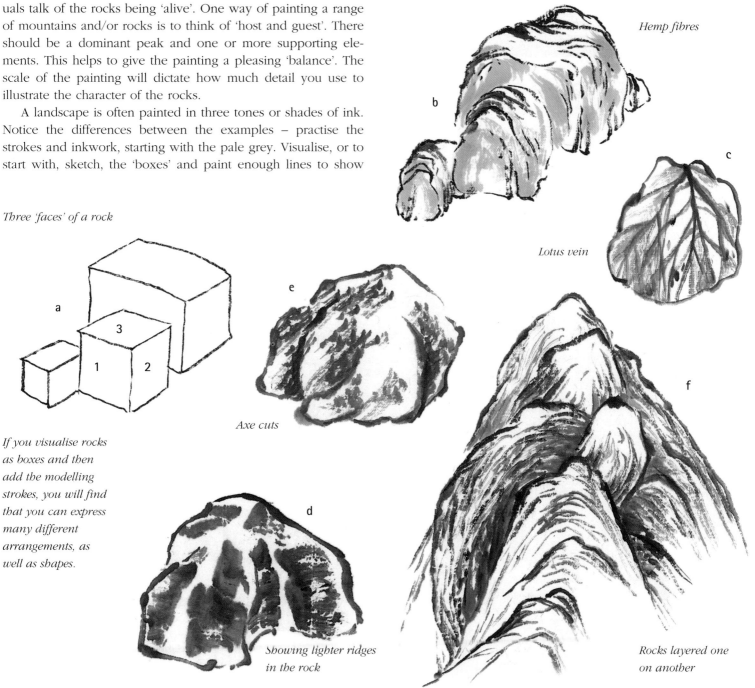

Hemp fibres

Lotus vein

Three 'faces' of a rock

If you visualise rocks as boxes and then add the modelling strokes, you will find that you can express many different arrangements, as well as shapes.

Axe cuts

Showing lighter ridges in the rock

Rocks layered one on another

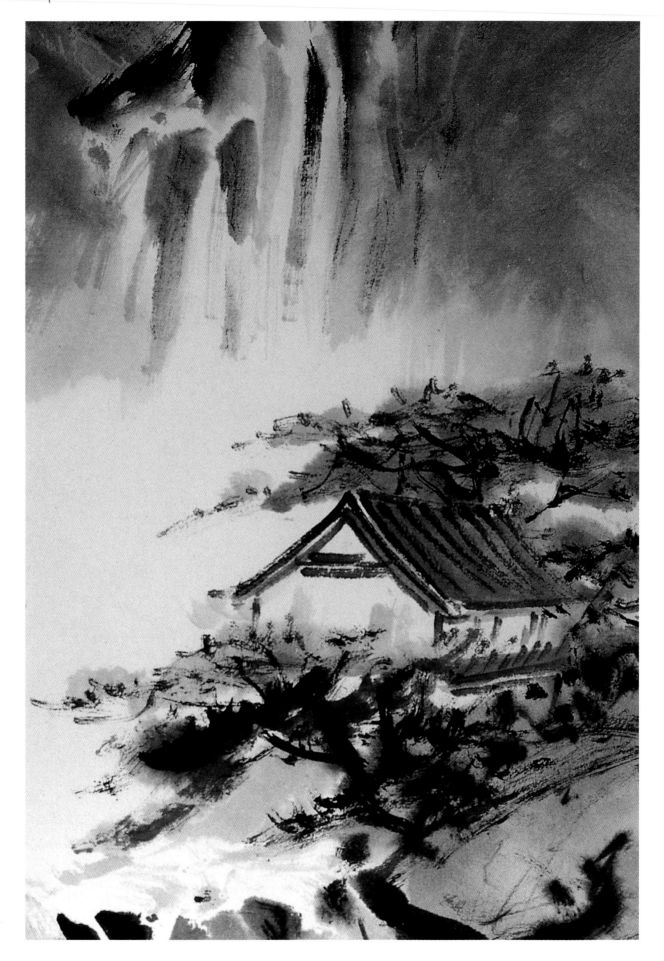

Water

Rushing water, furious waterfalls, even placid lakes, add movement to a landscape. Water flows into the spaces left by the rocks and creates the marvellous mists that are so typical of Chinese scenery. Both water and mist can be painted – that is to say, shown in some detail using light colour. But more often they are described by leaving the paper blank, which emphasises the difference in character from the solid to the flexible. If the sky is painted (again, this is usually shown by blank paper), then some Chinese artists believe that the lake/water should be painted ,too, and vice versa.

Detail of a landscape by Joseph Lo.

Trees

Trees can soften a scene and mark the seasons with colour, shape and amount of growth. They can also indicate weather and conditions. In order to facilitate this, different shapes and styles are used for the foliage of many tree types, such as pine, maple, willow, round-leafed, fine-leafed, single-leafed and multi-lobed leafed trees etc. Used either in outline or as solid strokes, these patterns can suggest delicate or robust growth. Likewise, the trunks and branches also help to show the character of the trees. The amount of detail, such as marking on the trunk of a pine tree, for instance, will depend on the size of that tree in the landscape. Pay attention to the attitude of the various trees: some are stiff and upright, others are soft and drooping. These strokes also have particular names: 'crab's claw', 'feather', 'pepper dots', 'rice dots' and 'bowed-head dots' are just a few.

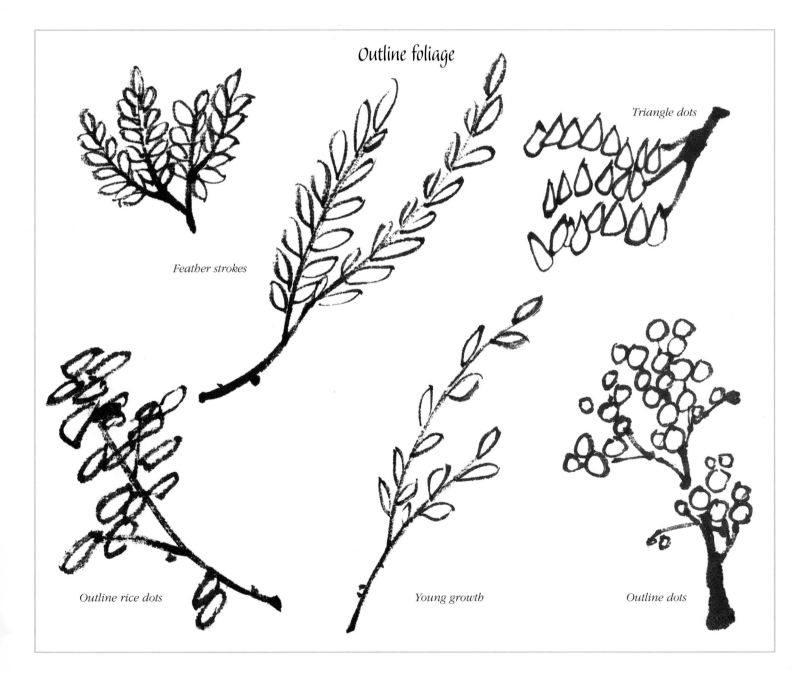

Outline foliage

Feather strokes

Triangle dots

Outline rice dots

Young growth

Outline dots

Solid-stroke foliage

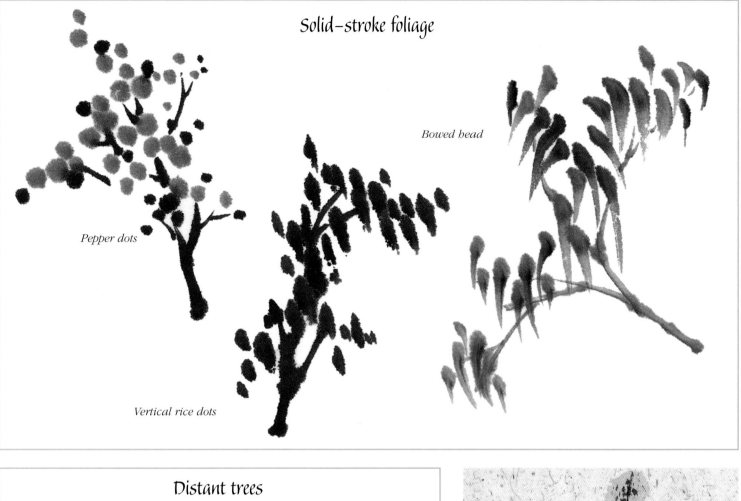

Pepper dots

Bowed head

Vertical rice dots

Distant trees

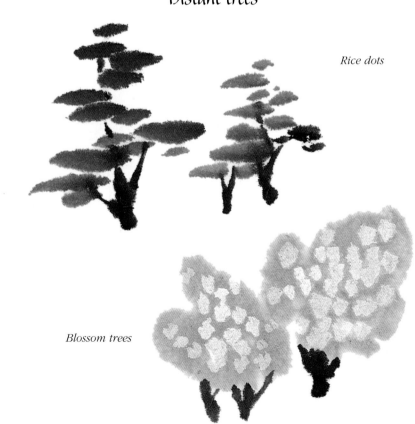

Rice dots

Blossom trees

Small tree study.

Pine.

The amount of detail on the trunk of a tree will depend on the scale of the painting.

Autumn foliage.

Small tree study.

Bonsai

Bonsai trees are popular in both China and Japan. Another work by Joseph Lo, part of a series, shows a wonderful, twisted pine tree in a pottery container. The contrast between the smooth dish and the rough surface of the tree is very marked, and this choice is often made to show the variation, and to add drama to the composition. Both elements owe something to man's activities – the bowl has been formed by a potter, while over a long time span the tree has been guided into portraying a miniature scene.

Fisherman under a willow

Traditionally, trees are shown in groups, often of varied species. The landscape showing a fisherman under a willow, with a mountain backdrop, suggests a shady spot on a breezy summer's day.

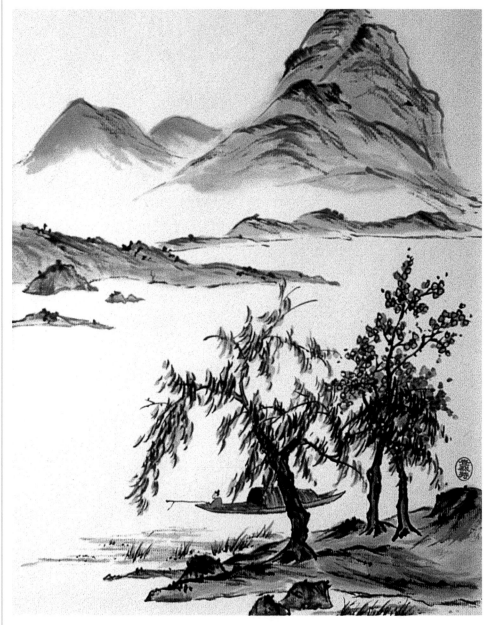

This painting has a very tranquil feel to it. The fisherman is peacefully sitting under the shelter of the willow, itself a soft and gentle influence.

2 Add the ground under the trees, allowing variation in the strokes and the spaces. Paint the boat, complete with the man fishing. Ensure that his activity is obvious, but do not make the strokes too thick or clumsy.

3 Paint the next layer of ground on the other side of the lake, also in ink, but using less detail to emphasise the idea of distance. Finally, add the mountains, using fewer lines and lighter ink. You may even leave one of the distant peaks to be painted in colour only.

4 Using light colour,s, complete the painting. Traditional colours are burnt sienna and sky blue, with maybe some indigo right in the distance, with little or no inkwork. The greens could be yellow-greens, with small leaves for spring, or blue-greens and luxuriant foliage for summer. Bright, warm colours would be required for autumn.

1 Begin with the tree group, using shades of ink, and paying attention to the differences in foliage and shapes of the branches and trunks. Concentrate on achieving dense and sparse areas, large and small groups of foliage and thick or thin branches.

Adding a seal

The Completion chapter (page 117) will look at adding a seal to paintings. The seal example shown would be a very appropriate finishing touch to this painting.

Carved by Fu Kaili, this seal says 'Happy to go fishing in the shade of willows'.

Waterfall

By contrast, the waterfall seems noisy and active. Two examples are given here. The first is shown in the ink stage only, but should be completed in colour. Everything about these compositions has more impact – the amount of texture, the details, as well as the height and drama of the rocks edging the waterfalls.

To illustrate a different technique, another of Joseph Lo's paintings is illustrated, which gives more of an impression of force and mist rather than detailing it. A painting like this is best viewed from arm's length rather than examining it in detail.

1 Use two shades of ink to paint the main elements and texture in the scene. Remember that the principles of 'light/dark' and 'large/small' refer to spaces, as well as brush strokes.

2 Add some 'wet' (usually light) ink to obtain further variation. The second example is more complex in composition than the first. Note how the water is expressed by space. Add darker ink where desired to show foliage or greater depth.

3 Finally, add the light colour, painting over the ink lines and strokes to give subtlety. Use burnt sienna and sky blue, using more brown in the foreground, blending and converting to the blue for distance.

Buildings and people

Buildings and people are used to show the insignificant presence of mankind against the grandeur of nature. Houses or temples are painted nestling into a hillside or half-hidden in trees. The roof design can be ornate and interesting, often leaving no doubt which country is portrayed. Other roofs may be very rural, perhaps thatched, hinting at poverty or simplicity. Gateways and fences imply that there is a shrine or garden just out of sight.

Bridges, viewing points and shelters may fulfil the same purpose. They suggest the movement of people through a landscape, even if there is no one in sight. They often provide a spot of bright colour within the scene. Boats and carts show the activities of the people, adding movement or inactivity as the pose suggests. Boats can be shown at different scales to increase the

feeling of distance, and to confirm that the space in the painting is water. They can be shown singly or in a fleet. Pleasure boats suggest leisurely activity. In some paintings the boats will suggest travel between villages where the terrain is inhospitable., and goods going to market.

When painting people in a landscape, consider the amount of detail required. Usually clothes are shown with just a few lines, so as not to detract from the landscape itself. There is a choice to be made between painting the figures with a landscape background or populating a landscape with the people living in it. The scholar and his servant show in a conventional way the difference between the two, with the smaller figure carrying a package to demonstrate the difference in their stations. The musician

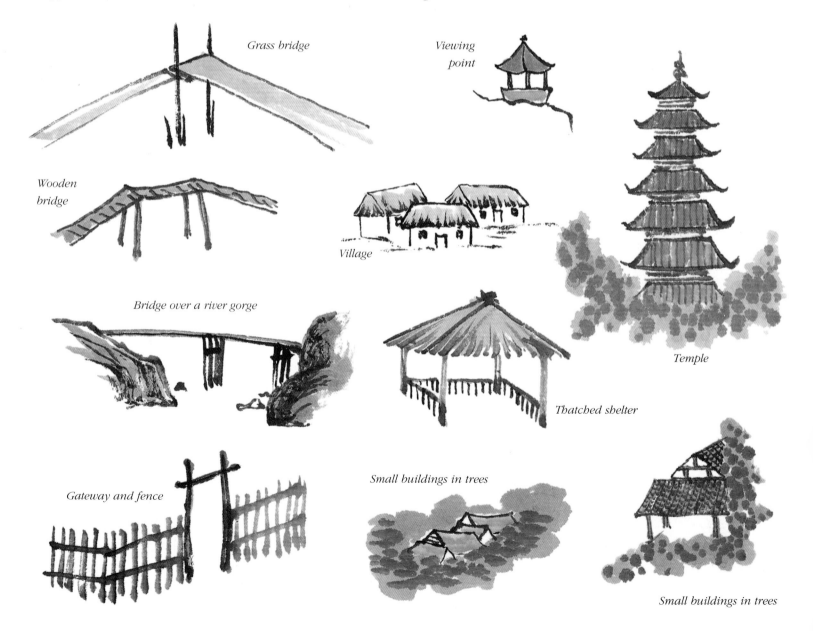

Grass bridge

Viewing point

Wooden bridge

Village

Bridge over a river gorge

Temple

Thatched shelter

Gateway and fence

Small buildings in trees

Small buildings in trees

playing in long, flowing robe suggests leisure time, the mat he is sitting on the presence of servants to fetch and carry for him. For tranquillity, the other small sitting figure could be meditating. Notice the slight, but different head angles suggested for this one – they hint at other activities without any surroundings being shown.

The pine-tree landscape on page 104 is based on an idea by Jenny Scott, and shows waterfalls and twisted pines on moun-tains receding into the distance. The foreground was painted first and the background gradually added. Ink painting was carried out before adding colour. Notice how the pine-tree-foliage canopy curves down to each side, whereas the waterfall paint-ing shows a more horizontal version.

When adding colour to pine trees, keep the colour inside the needle area to increase the spiky feeling. Otherwise, let the colour overflow to suggest that the areas of foliage extend fur-

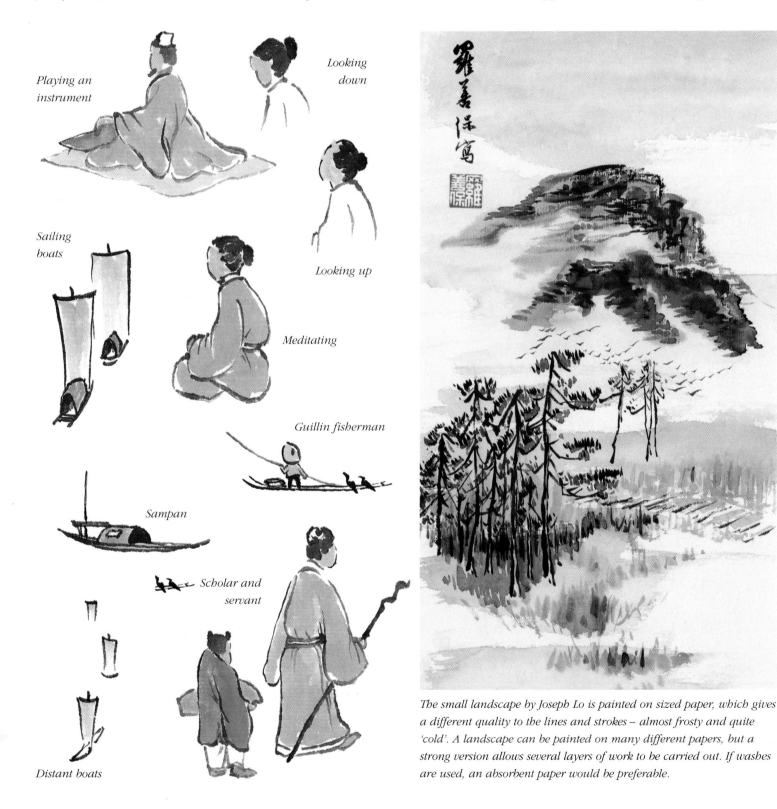

Playing an instrument

Looking down

Looking up

Sailing boats

Meditating

Guillin fisherman

Sampan

Scholar and servant

Distant boats

The small landscape by Joseph Lo is painted on sized paper, which gives a different quality to the lines and strokes – almost frosty and quite 'cold'. A landscape can be painted on many different papers, but a strong version allows several layers of work to be carried out. If washes are used, an absorbent paper would be preferable.

ther, but without showing the detail of the needles. The number of needles used is optional, but the centre one is usually painted first, followed by those on either side. Pine trees need both large and small needles, large and small groups of foliage, and different spaces between them.

The fisherman in his boat is by Joseph Lo. This painting is halfway between a landscape and a figure painting. Notice how the fisherman is looking into the painting and at the bamboo along the edge of the water, yet the fishing rod is facing the outer edge of the scene – maybe he has heard a fish jumping. It sets up a drama which makes this a very satisfactory painting.

Contemporary landscape styles are not always what the Western viewer expects. They are often brooding or very colourful. The folk-art influence of many rural communities is bound to have had an effect on the local fine-art styles over the years.

Pine and distant water landscape.

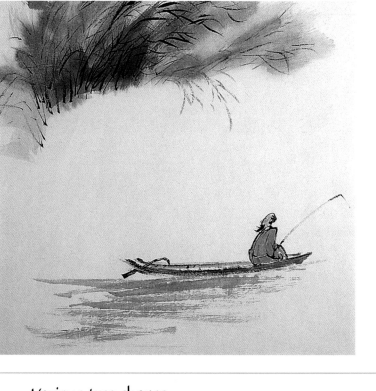

Fisherman and bamboo by Joseph Lo.

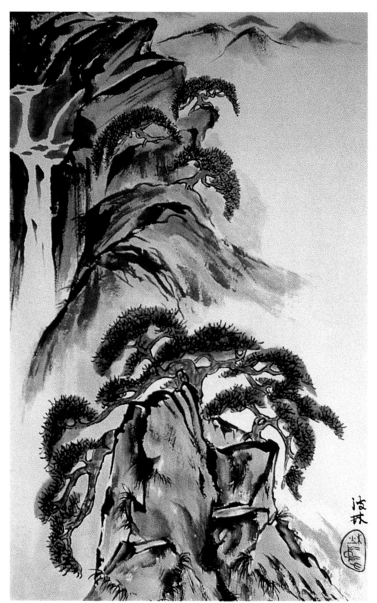

Various tree shapes

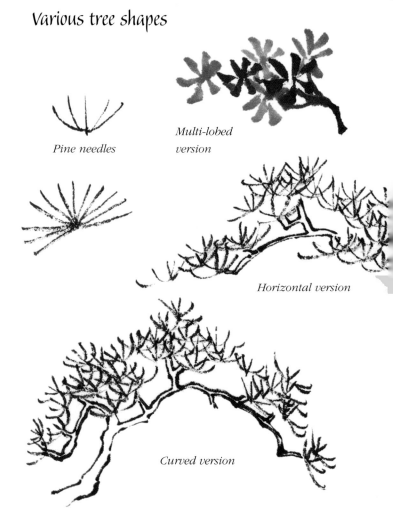

Pine needles

Multi-lobed version

Horizontal version

Curved version

Hu Fang comes originally from Sichuan. Her memories of the countryside, and travels to Tibet, have had a strong influence on her work. Her landscapes are cheerful and lively, with some being evocative of the life around that area. Her work has been exhibited in major Chinese galleries, as well as in the West. Two of her paintings are illustrated here in slightly different styles. The moonlight scene is in a more traditional, peaceful style, with the dwellings sheltered by the trees. The fences on either side of the rushing river make you wonder how the inhabitants would travel from one side to the other. In the second picture, the houses and lake roasting in the sunshine glow with a wonderful, lively spirit. These are traditional buildings represented in an enchanting way. Many of the bright hues used are mineral colours, and the calligraphy mentions 'the lake in the distance' – but this can be both in space and in time. Finding appropriate sayings to add to a painting is difficult for the Western artist. Hu Fang has painted both the sky and the lake (rather than leaving the paper blank), adding to the dramatic painting.

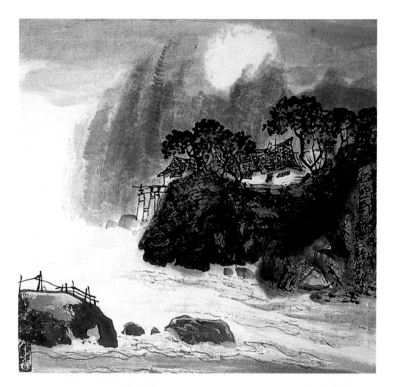

Below right Sunlit landscape plus 'distant water' *by Hu Fang.*

Moonlit landscape *by Hu Fang.*

Maple

Intertwined trees

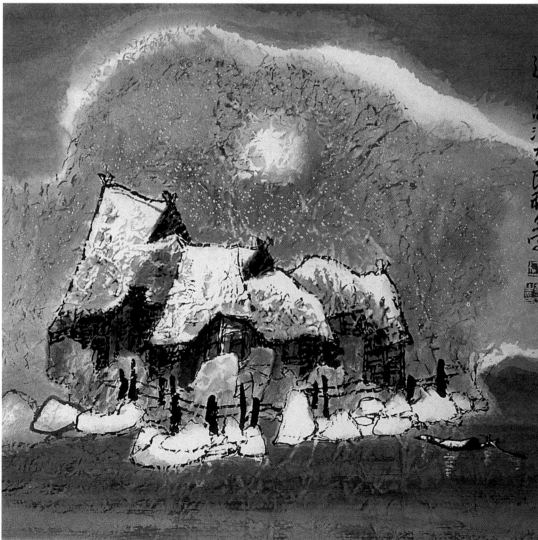

Another Chinese artist using mineral colours to contrast with the ink is Fu Kaili, who now teaches Chinese brush painting in England. This beautiful landscape, featuring the Lake District in autumn, is very much in Chinese style (Kaili spent about a week in the Watermill area, sketching and painting). This scene shows the autumn colours, while suggesting a tranquillity in the smooth surface of the water. A slight breeze is hinted at by the graceful passage of a yacht moving across the water to link the two halves of the scene. The mist in the distance shows how the scenery of that particular part of England is appropriate to this evocative painting style. Note how the buildings have a Chinese feel to them, however.

In order to make mineral colours really stand out, paint with dark ink first (lighter in the distance), and, when it is dry, add the bright, mineral colours. Powder pigments would obviously be best here, but

they are complex to use and require a glue binder, pestle and mortar for mixing. Tube paints can be used instead and are more readily available, but do not give the same strength of pigment or as many shades. Some traditional Sung Dynasty landscapes (characterised by great blue/green landscapes) used mineral colours on both sides of the painting.

A detail from another of Joseph Lo's landscapes shows how he has used the bright, opaque, mineral colours as a foil for the dark ink strokes.

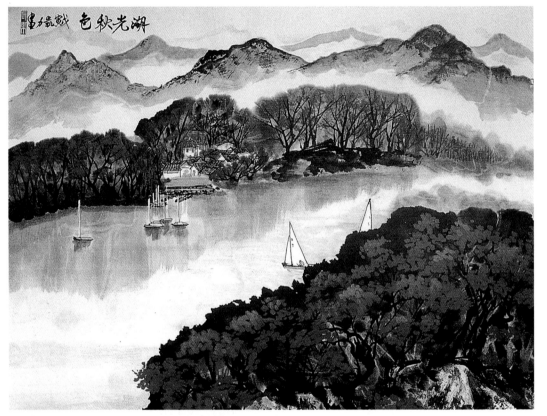

Lakeland landscape
using mineral paints by Kaili Fu.

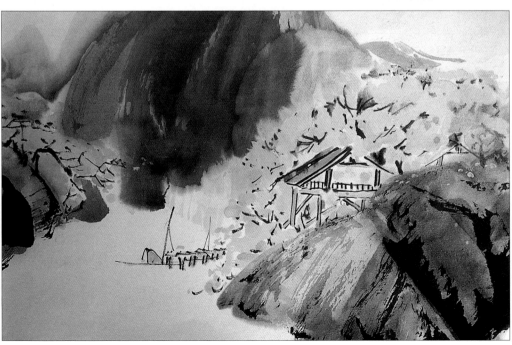

Detail of landscape using mineral yellow by Joseph Lo.

More advanced techniques

More advanced techniques

Once the basics have been mastered – and you will need plenty of practice – there are many fascinating techniques that can be learnt and explored. By experimenting with different papers, inks, colours and brushes, you will understand the materials and the techniques. In China, students concentrate enormously on brushwork, especially fine linework, during an artist's training. In the West, we are not so good at spending hours doing the same exercise over and over again. We also need to learn about the design and composition of the work, whereas Orientals have absorbed it during their lifetime. In the West, therefore, fine-line and meticulous painting tend to be part of a more advanced programme.

Meticulous style

The meticulous style of painting requires either sized paper or sized silk (white or pale colours). It is possible to size the surface yourself with alum and glue, but difficult to get even results – and it is more fun to spend your time painting! The *Gongbi* style requires a considerable amount of patient work in order to build up lines and shades of ink before colour is added (*bai miao*). A light subject needs pale ink for lines and darker ink for dark areas. For example, flesh is paler than many clothes, so light ink is required, indicating a different surface to fabric.

With reds, you can paint a thin alum solution over the subject (a teaspoon of alum powder to a pint of warm water) between washes and before mounting.

A stunningly beautiful example of this style, called *Spring*, by Fu Kaili, is illustrated, from scrolls called *The Four Seasons*. Kaili

Gongbi lotus

After the linework, add light ink washes to suggest the form of leaves or petals.

1 Using two brushes (e.g. 'white cloud'), one containing the wash colour, the other just damp, first paint a small area of colour, keeping the tip of the brush to an edge or vein line. Immediately use the second brush to take away the excess where the heel of the brush touched the paper or silk, ensuring a soft blending of colour.

2 Each time you add more pigment, follow a slightly different, but overlapping area.

3 Use a minimum of two ink washes for leaves, plus at least one of indigo. This will show the modelling of the leaf.

4 Lastly, mix indigo and yellow together (to form green) and wash the whole of the leaf. (For dark-red petals you need about nine layers.) Do not hurry – if the layers of pigment are too thick, you will have problems backing the silk or paper.

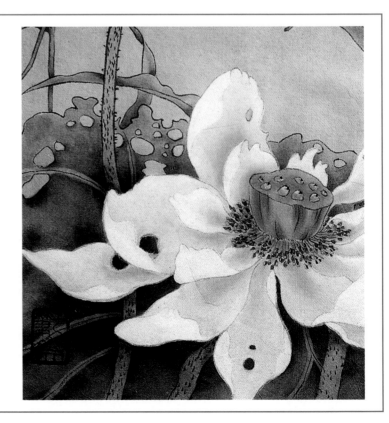

referred to some figure books for this painting. It represents hours of patient work, building up layers of paint washes.

Another example is a detail from a painting by the author (with help from Cai Xiaoli, who taught her this technique), painted from a well-known *Gongbi*-style Chinese painting, showing how the same principles can be used for flowers. If following a painting with straight stems, paint them curved to give more spirit, or *qi*, and remember the light/dark, dense/sparse principles. Vary the shading underneath (indigo under cold colours and ink for warmth). Once the painting is backed, you may need more layers, so be patient. The end result is well worth taking time and effort over.

In meticulous landscapes, indigo (cold) and burnt sienna (warm) are used as the underwashes. Mineral colours are required to imitate two main styles: the great or the small, blue/green landscape. These are malachite and azurite, each having four shades. A firmer, wolf brush and 'hide-the-tip' strokes are used frequently, with a variety of linework, both in structure and texture. Cai Xiaoli uses the expression 'brave to start, careful to finish' – this is also true of freestyle work.

These techniques are difficult to learn from a book because of the number of stages and the need for guidance. However, a greater understanding of the complexity of *Gongbi* painting on silk can only add to your enjoyment of looking at this style.

Meticulous blossom

An easier use of sized paper is the illustrated branches of blossom. The results are unpredictable, and therefore exciting!

3 The flowers are carried out by making five small petals in dark yellow or orange.

4 Then add to each one with a brush loaded with white, then light yellow.

5 Your composition can include rocks using the same technique. It can also be used for leaves and other plant material, but beware of making your painting boring by including too much pattern or variation.

1 Paint the stem quickly, using either clean water or very light ink. Vary the width of your stroke.

2 Without delay, add ink and/or colour randomly to the wet areas and watch it move. You can add more ink, or colour, or remove some with a damp brush. The branch will dry back by about 50 per cent, so make it darker than you want.

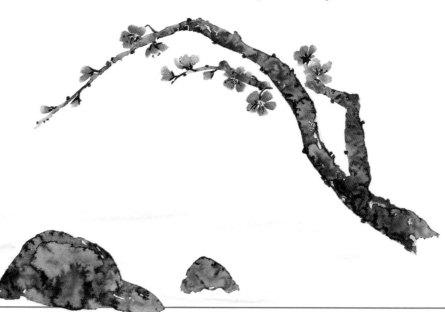

Multi-wash technique

Another style using bai miao and hemp fibre, straw paper or a similar strong paper, which is also textured with long fibres. It is ideal for subjects such as the lotus and fish illustrated.

1 Start the flowers in light ink, and the darker leaves. Add the stems in single strokes and light ink, or you may prefer outline (two strokes from the leaf down, giving the effect of passing into water). Paint the fish, either starting with the back, or by using the fine brush for detail first. If you are unsure about composition, practise on another paper, cut out the results and move the fish around to achieve the right arrangement.

2 Proceed to ink washes for some shading (this shows front and back, rather than shadows), before going on to colour.

3 Do not try to hurry this stage. It is better to relax and enjoy the painting. Once satisfied with the depth of colour, add background washes for the water. Dampen areas of the painting beforehand, or paint a water line around your last stroke in order to obtain a soft transition in the layers and washes. These papers will dry back by about 50 per cent, so keep adding colour washes in order to make it dramatic enough. Notice how the washes are started at the top of the painting.

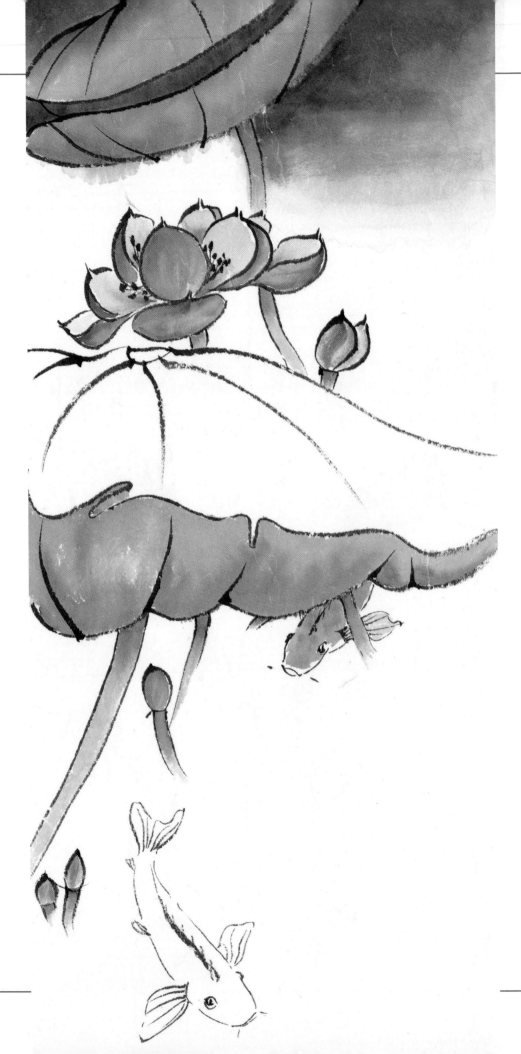

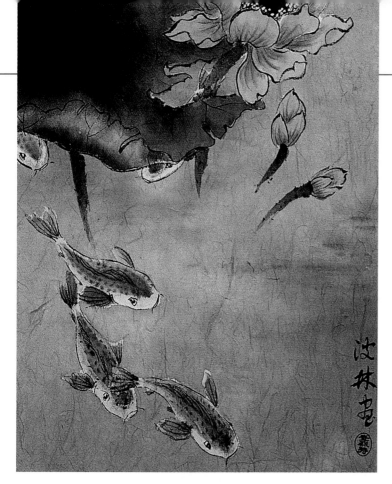

Included are two examples showing how textured paper and more washes can achieve a very different result. One example uses the texture of the paper with a fairly even wash. The second painting shows more drama and depth. If you find that the washes are spreading into the fish too much, add white paint, such as gouache, to the fish (on the back of the paper) to make them appear silvery. Paintings on absorbent paper will become paler by approximately 30 per cent.

Fish with golden lotus – multi-wash technique on long-fibre painting.

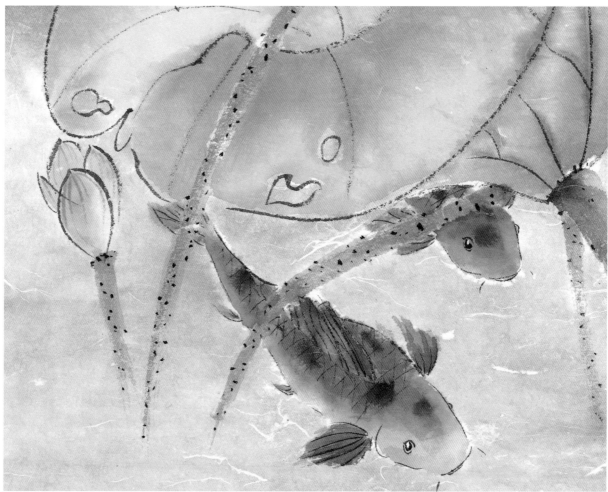

Lighter wash version of Lotus with fish.

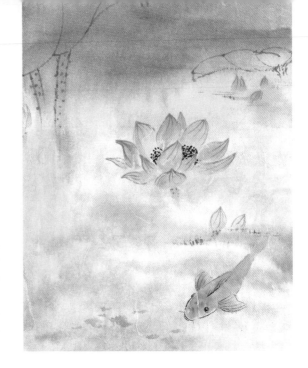

Add random washes to a blank sheet of paper and add details later. It is better to wait and look for a while, maybe for days or longer, to see what you can 'see' in the coloured washes. In the examples, the landscape (see below) was painted 'upside down' and then later reversed. The yellow lotus (see right) was suggested by a concentrated patch of colour and was later exaggerated. Sometimes you gain more freedom with this approach.

Alum

Another way to ensure that fish remain light is to paint them with an alum solution. Alum can also be used for the scales on fish, dragons or lizards. Change the strength to obtain differing effects and let the alum dry before painting over the top. This does not work well on sized paper, as the alum must soak into the paper.

An alternative use is to paint the path of a waterfall with alum prior to painting the rocky sides. The illustration shows how this may appear in a final painting. Or you could create wonderful silver birches or tree trunks with light bark.

Meticulous figure painting on sized paper by Kaili Fu. Original is scroll mounted.

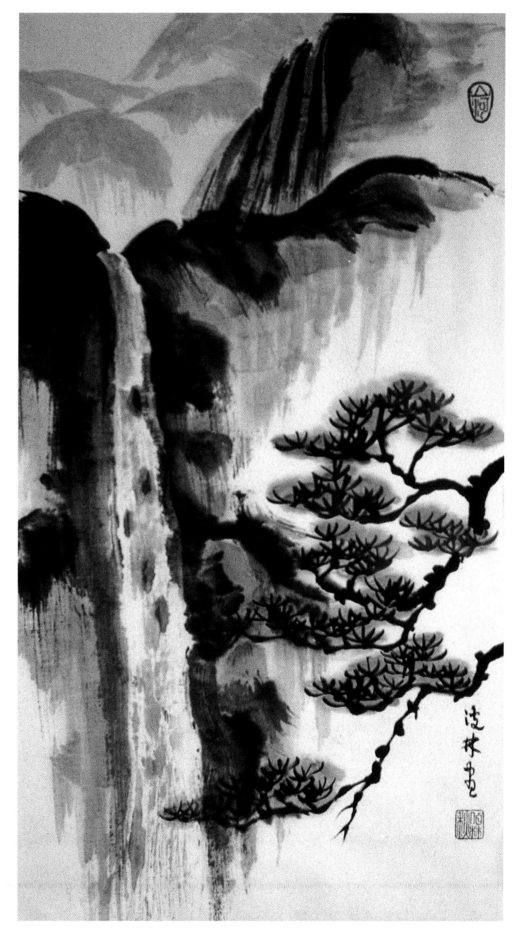

Landscape with waterfall, *using the alum-resist technique.*

Wrinkle technique

This can be used to great effect with rocks or mountains. For jagged mountains, crinkle paper and wipe the brush over the high points; for softness, spray the paper between wrinkling and adding ink.

To create another effect, paint the ink on and then spray it with water – the ink will spread dramatically. Second and third layers can be carried out in light ink or colour, but it is best to allow the paper to dry in between. The detail from a landscape by Hu Fang shows how effective this can be. Different papers will give varying results.

Wrinkle amd paint 'mountains', spray with water and the ink will spread.

Wrinkle and paint 'mountains' with ink – use for sharp rock formations.

Wrinkle, spray with water and then paint 'mountains' – the result is much softer.

Let dry, wrinkle again and paint 'mountains' with light grey to give variation.

Detail showing the wrinkle technique from a painting by Hu Fang.

Coloured paper

Even the freestyle work has variations. Dyed *xuan* papers are similar to a slightly sized paper. They are useful for painting white subjects without having to do a backwash for them to show up. For some painters who prefer a non-white paper, it can be more sympathetic. The colours are based on the traditional colours from past dynasties, such as Sung and Ming, and are useful for landscape painting, giving a softness without washes. Many of these coloured papers also have gold flecks in them. These are best used for inkwork. Bright-red paper is available, but this tends to be used for calligraphy, especially at New Year.

Running ink

With thicker, two- or three-ply paper, you can indulge in making the ink run. Paint a shape and immediately fill it with a wash – the lines will blur as in the examples, given by Dai Ying. These are details from large paintings.

Lotus pods *by Dai Ying*.

Detail of Red peonies
by Dai Ying.

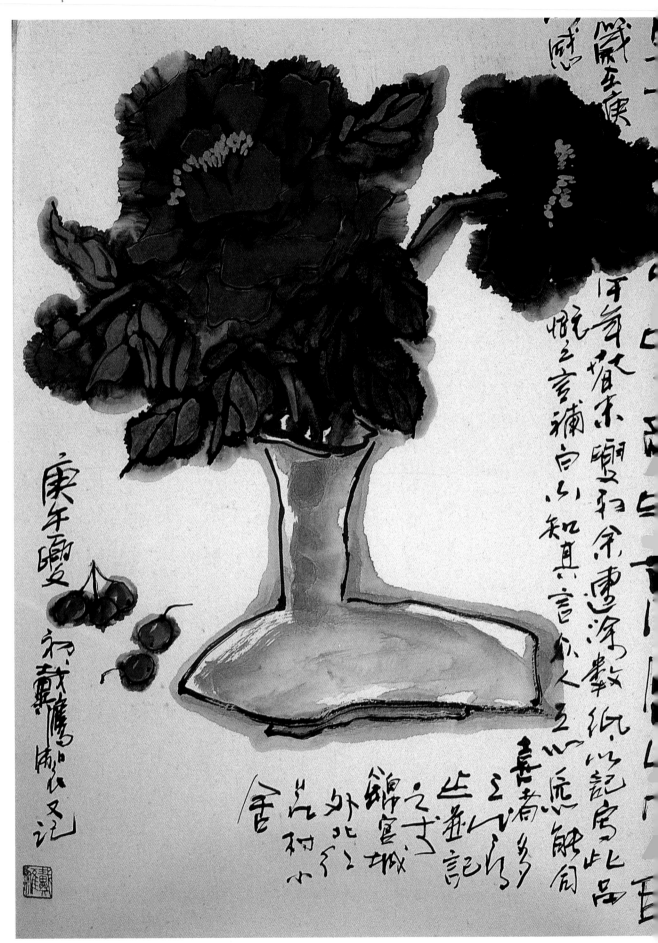

Vase of peonies *by Dai Ying, which was painted using the running-ink technique.*

Completion

柳漁夫下

Completion

Traditionally, a painting in this art form is not complete without calligraphy and a seal. This is easier for the Oriental artist, who is familiar with the written language and apt sayings that feature on many paintings. Many tourists travel to Hong Kong and return with their own seal or 'chop'. These are not necessarily suitable for application to a painting, as many of the designs, especially those with both Chinese and English, are not well regarded in the art world.

Calligraphy

In the West, children start by learning the printed letters. In China, this equates to the regular, or *kai shu*, characters. Once this has been understood (rather than mastered), attempts can be made at the other styles. There are times when a certain style of calligraphy will be more appropriate than others – we cannot always appreciate this. The best way to learn is to examine paintings, look at the style used, and ask 'why'?

Ancient or seal scripts were the earliest, evolving from the pictograms used by shamans for divination. They were first inscribed onto turtle shells and bones. An imperial decree stated that clerical script was to be the unified calligraphy of China, and, over time, this gradually changed to the regular script. There are also 'handwriting' versions, usually referred to as 'cursive' and 'running', which are more difficult to use as they require a basic knowledge of Chinese characters.

It is sensible to learn a few phrases, or to learn how to write your name. The phonetic translation depends on dialect, or where the Chinese teacher comes from. Pronunciation in Mandarin is different from Cantonese, for example. The name, character or phrase (as painting and calligraphy are so akin to each other, a painting is often described as being 'written') must be positioned carefully on the painting. It is usually not placed where we would position it on a Western work. Leave one corner free and study paintings in books and exhibitions to gain a feeling for composition. A seal is often placed in association with the calligraphy.

A few examples in regular style are given for practice. Think about more unusual ideas. The landscape by Qu Lei Lei has 'Heaven understands the emotion of the poets – the view of the sunset is infinite, you cannot really see the forests, only hear the birds in the empty hills' travelling along the horizon, which could suggest the last rays of the setting sun.

The eight basic calligraphy strokes

Calligraphy taken across the hills of this landscape by Qu Lei Lei.

Calligraphy in light ink to complement the watery feel of this painting by Dai Ying.

魚樂

Fishes happiness

龍

Dragon

蛇

Snake

米

Rice

猫

Cat

柳林燕

Swallows in the willow wood

柳渔夫下

Fisherman under the willow tree

花

Flower

红

Red + flower

蓝

Blue + flower = orchid

色的

Blue (adjective) + flower = Blue flower

犬

Dog

黄

Yellow + flower

美

Beauty

猴

Monkey

Seals

Seals are carved from various stones, often with animals perched on the top. The carving can be *yin* (intaglio, with white characters on red) or *yang* (relief, with red characters on white) or a mixture of the two. More than one seal may be used on a painting, but if used close together, the *yin* seal should be at the bottom. As the Chinese place their surnames in front of their given names, the latter is the heavier-looking of the two. Artists who carve their own seals use different ones at various stages of their life. This practice can be used to date paintings.

Seals can also contain a message or saying which may be general or personal. These are also placed with consideration. You will require a pot of red cinnabar paste – the seal is placed into the paste and then applied to the painting. Be careful not to smudge it while wet, and ensure that it is the correct way up.

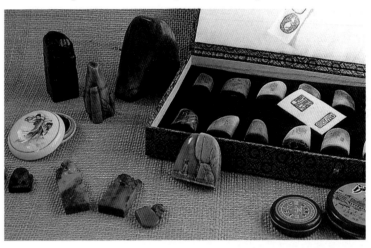

Various examples (old and new) of seals and seal paste.

The twelve seals of the zodiac animals (both yin and yang)

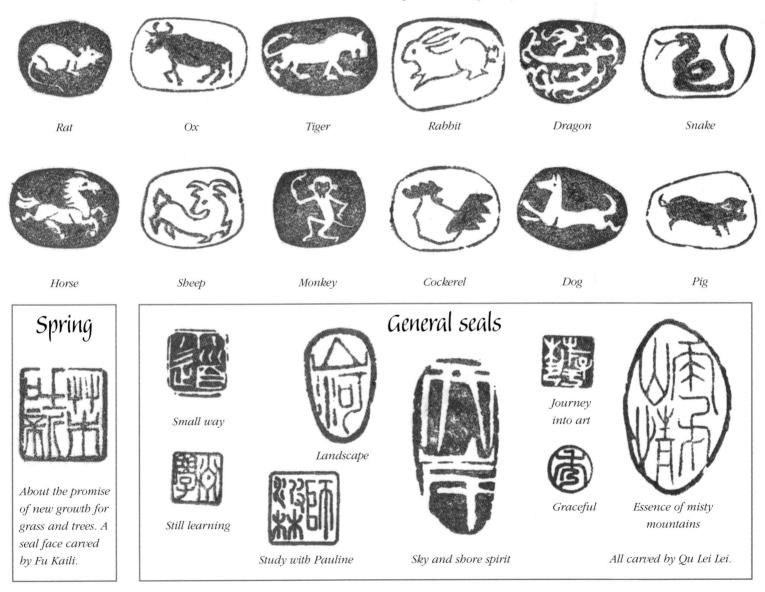

Rat	*Ox*	*Tiger*	*Rabbit*	*Dragon*	*Snake*
Horse	*Sheep*	*Monkey*	*Cockerel*	*Dog*	*Pig*

Spring

About the promise of new growth for grass and trees. A seal face carved by Fu Kaili.

General seals

Small way

Still learning

Landscape

Study with Pauline

Sky and shore spirit

Journey into art

Graceful

Essence of misty mountains

All carved by Qu Lei Lei.

Backing

A finished painting needs backing for ideal presentation. However the work is to be framed, flatten any wrinkles by spraying the back of the painting and brushing it with a dry brush. The backing process is also called mounting.

Mounting/backing equipment.

You will need:

- cold-water starch paste (or make up your own using wheat-starch flour, water and a few drops of formaldehyde, then heat to 80˚F to dissolve)
- a wide pasting brush
- a narrow brush (a 25mm paintbrush will suffice)
- a wide, dry brush
- a polished work surface, e.g. a kitchen worktop
- a tube or broom handle
- a straw – preferably a bendable one
- a door or painted/varnished surface on which to hang the pasted painting while it is drying.

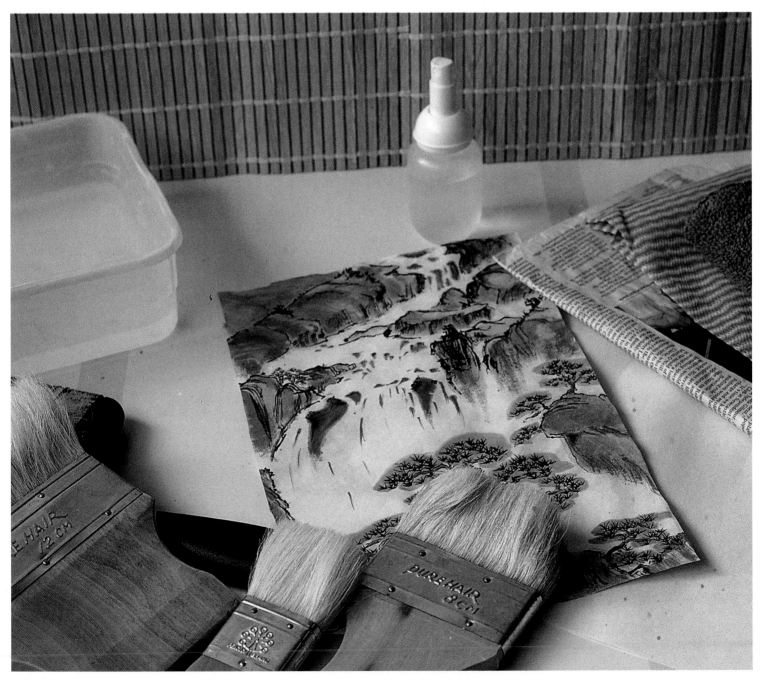

4 Take a sheet of newspaper, lift a narrow edge of the pasted paper with one edge of the newspaper and then lift both, flipping the newspaper behind the backing paper (pasted side uppermost). Lay to one side. Clean and dry the table.

5 Making sure that the painting is face down on the table, carefully flatten with a dry brush.

1 Cut the backing paper, which should be the same as the painting (such as bark or Japanese 'Moon Palace', but not grass paper) at least 25mm (1 inch) larger all round.

2 Polish the table and lay the painting face down. Lightly spray the back of the painting with clean water, brush with a dry brush to remove wrinkles, put to one side. Dry the table.

3 Check the backing for hairs and lay smooth side up. Paste evenly. don't worry about wrinkles forming.

6 Slide a tube or broom handle under one end of the pasted paper, leaving the other hand free for positioning. Start at one end (if you are right-handed, have the tube in your left hand and brush in the right) and gradually lower the pasted paper onto the back of the painting and brush gently with a dry brush while lowering the tube. Increase the pressure, working from side to side and from one end to the other.

7 When the two sheets are bonded, paste the margin around the painting with a small brush. Lift the bonded sheets from one end using as many fingers as possible, rather than just your finger and thumb, or maybe use a piece of newspaper as reinforcement along the lifting edge.

8 Place the top of the painting against a veneered or painted door and let gravity settle the sheet. Adjust the margin so that it is flat and the pasted edge adheres all round. Take a straw (bent variety is best) and lightly blow some air in at one of the lower corners to form a slight cushion. Seal the corner and leave overnight.

9 When it is dry and flat, remove the painting and trim it to the required size. As the paste is water-based, a wet cloth will remove any excess traces from the door.

An alternative surface could be a piece of board that can be propped up – it is easier to place the painting onto a vertical surface. If a more substantial backing is required, two or three sheets can be added at the same time, following stages 3 to 6. Additional drying time will be required. This technique is used in Chinese mounting studios and puts the painting at less risk than if the back of the painting itself is pasted. The colours are now brighter, and the paste has strengthened the bond between the paper and the ink or pigment.

For silk, the process is similar, except that the paste is mixed to a thicker consistency and the back of the painting is pasted and a dry backing paper lowered onto the silk and brushed out as before. This method needs practice before using it on your favourite piece of work.

Once the painting has been backed, it can be framed behind glass. Use either an aperture mount with the accepted margin conventions, or place the picture straight into a simple, plain frame. Different proportions apply to scroll-mounted pictures, which are a very expensive option, with few sources in the West. With pollution and central heating rife, it is best to protect your work in a frame. Some examples are shown for you to consider. Try to complement either a colour in your painting or the paper.

Using a card mount and frame of the same colour can enhance a delicate painting. Remember that the glass will change the aperture-mount colour.

Many Chinese artists in the West favour heavy, dark frames.

Framing using natural colours to complement a darker paper.

Silk or paper brocade can be enhanced by using a simple meta' frame.

Conclusion

Everyone has different taste, but there are so many variations, techniques and styles within Chinese brush painting, that there is something for everyone. There is often humour in the bird and animal paintings - or maybe laughter at our own efforts! Many of the paintings do not take long to paint, so if a painting does not go well, or to your satisfaction, try again. If success eludes you, take a break from that subject. If all else fails, transfer to another subject or try again another day. Practice is important, especially for calligraphy and strokes. Make the brush dance across the paper - fluid and carefree strokes are necessary for all the styles of Chinese brush painting.

You may decide that you prefer the more meticulous or 'tidy' styles; or you may be searching for more freedom in other artwork. There is plenty to choose from. A superficial approach may be your preference, but there are many aspects of this art form to enjoy, and so much to learn and absorb if you wish. Experiment to find your own style.

You can become immersed in the culture, the legends, history, geography and the daily lives of the Chinese people (both past and present). There is tremendous interest in Oriental matters, some wonderful books, programmes and videos. The choices of specialist tours, for sightseeing or painting are increasing each year. All this assists in a greater understanding of the arts, crafts and materials, also their impact on both China and the West. Try to be open to inspiration from many sources.

For me the pleasure is to continue to learn, to find something new - either by exploration or by research. I am very grateful to those artists who have shared their knowledge and skills with me, and am delighted to share those discoveries with others.

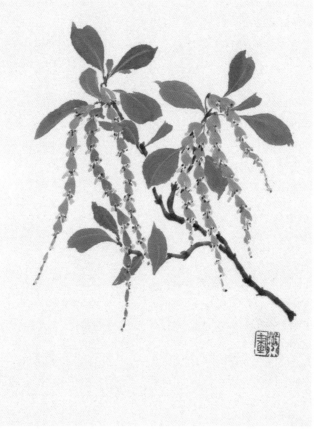

The long silky tassels of Garryea Eliptica show plenty of movement.

Detail of traditional landscape by Ya Min.

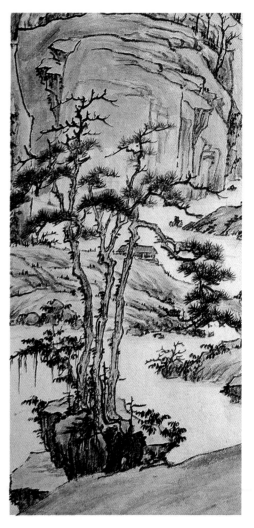

Index

Credits and acknowledgements

Special thanks to the artists who have kindly given permission for their work to be included. Efforts to contact Ya Min have been unsuccessful. Ms Hu Fang can be contacted via 01202 259115.

Photography by Pauline and David Cherrett

For painting supplies, try Chinatown shops, and specialist art shops - some teachers will have stock to sell or can advise the best supplier. For details of courses try the NIACE booklet or ARCA Colleges (both in UK) – **www.aredu.org.uk** *information from libraries. Or contact the Chinese Brush Painters Society at* http://www.welcome.to/chinese.brush.painters.society *or the Sumi-e Society of America at* http://www.geocities.com/Tokyo/Springs/4458.

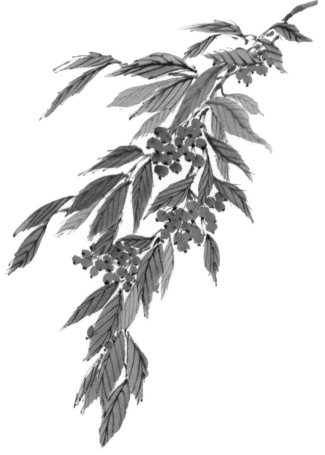